The Albums of James Tissot

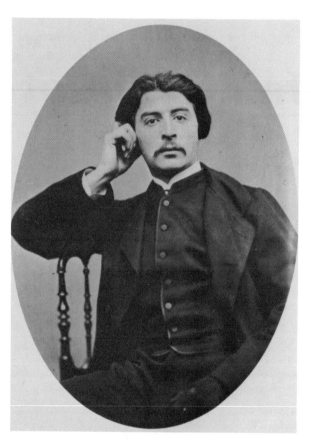

ca. 1865

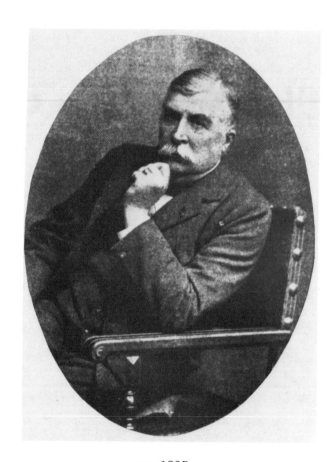

ca. 1895

James Tissot

The Albums of James Tissot

Willard E. Misfeldt

Bowling Green University Popular Press
Bowling Green, Ohio 43403
1982

Library of Congress Catalog No.: 82-82126

ISBN: 0-87972-209-6
 0-87972-210-X

To My Mother
Mrs. Jennie L. Misfeldt

Acknowledgments

Since learning in 1967 in the course of doctoral dissertation research that James Tissot had kept a set of photograph albums that provided a visual record of his painted oeuvre it has been my hope, first, to locate that record and, secondly, to preserve it and to make it accessible to the art-history profession and to other interested persons. The present publication achieves these ends to a limited degree. When I first saw this important primary material in 1970 I was struck by the generally poor state of preservation of the photographs that make up this unusual documentation. On the second viewing eleven years later I was struck by the increased deterioration of many of the photographs, some of them well over a hundred years old. It seemed important, even urgent, that something be done to preserve these original documents before they faded to the point of total uselessness, particularly as a large share of them are the sole record of lost or unlocated works. Thus, it is with the intent of preserving the primary material that comprises the three surviving albums of photographs that this publication is offered. Perhaps it will spark enough interest to bring out the missing second album of the original set of four albums and thus complete the record.

A number of people have contributed in diverse and important ways to the realization of this publication project. For valuable suggestions and practical assistance I should like to thank Dr. Ramona Cormier, Dr. Dawn Glanz, Dr. John C. Lavezzi, Mr. Dan Ward, and Mr. Mark Schaffer. For directing me to the albums of photographs that are here presented I should like to acknowledge Monsieur Charles Renoud-Grappin of Besançon, France, auctioneer at the sale at the Château de Buillon in 1964. I cherish the friendship that has developed with him and his family over the years. Monsieur Michael Brockmeyer of Paris, a staunch friend, was most helpful in a practical sense in carrying out this project. I am greatly indebted to him for his assistance and encouragement. To Monsieur Humbert Santander of Besançon, whose photographic skills have rescued and preserved these fading images, I am greatly indebted. Monsieur Marcel Vuillemot-Morel of Auxonne, France, who during the period of his ownership of the albums gave permission to have them copied for scholarly purposes, deserves a special expression of gratitude. He has played an important role in preserving these significant historical documents.

The honor of final recognition must be reserved for Monsieur Gérard Mantion of Besançon, present owner of the Château de Buillon. He and his charming wife, Élyane, have always received me with the greatest warmth on my several visits to Besançon. Their keen interest in everything that pertains to James Tissot has given them a sense of historical perspective and a sense of responsibilty to the future that are exemplary. Their continued interest and encouragement are deeply appreciated. I am especially indebted to Monsieur Mantion for arranging to have the albums copied. Without his help and his generous support this project would not have been possible.

It is, then, with a profound sense of both gratitude and humility that I offer these documents to the art-history profession. I am very pleased that the work I began on James Tissot in 1965, before any of the other scholars who have been working on him recently, has contributed to a fuller picture of an artist who does not deserve to be forgotten. It is my hope that the present publication will take that picture to a stage significantly closer to completeness.

Willard E. Misfeldt
Bowling Green, Ohio

Introduction

The James Tissot Albums

In May of 1882, in what was to be his last year in London, James Tissot held an exhibition of his work at the Dudley Gallery in Egyptian Hall in London's Piccadilly district. He called the showing "An Exhibition of Modern Art." Its modernity was emphasized in the title of a featured series of paintings, *The Prodigal Son in Modern Life*. Besides this series of four paintings, Tissot showed eight other paintings, fifty-seven prints dating from 1875 to 1882, a bronze and cloisonné enamel work called *Fortune*, and nineteen enamel pieces (including a group of enamel trial pieces). On page twelve of the catalogue for this exhibition was a brief notice concerning three albums of photographs of his work that Tissot was also showing.

The Complete Collection of the Artist's Works are reproduced in a Series of Photographs, which are contained in three Albums, also on view:

Vol. I.--1859-1870;
Vol. II.--1870-1876;
Vol. III.--1876-1882.

To someone doing research for a doctoral dissertation on Tissot, as the present author was in 1967 when he first came across this reference, such albums would have been a windfall providing a visual record of a large number of missing works, presumably along with dates and titles.[1] The albums were not to be found in any library or museum where one might suppose they would be preserved, nor were they to be found in any other art historical documentation center. Tissot's closest surviving collateral descendant, the late Madame Jean de Gournay of Paris, a grand-niece, knew nothing about them. They apparently had not been in Tissot's country home, the Château de Buillon near Besançon, France, when his last surviving niece, Jeanne Tissot, died there in July of 1964, nor, apparently, had they been among the items sold at the auction held at the château in the October following Jeanne Tissot's death, when her property was disposed of and her estate settled.

The albums remained elusive. The organizers of the Tissot retrospective exhibition that was held in Providence and Toronto in 1968 sought them as well, also in vain.[2] Then, unexpectedly, in 1970 the auctioneer for the sale at the château notified the present author that a set of albums did exist and that he could see them if he were to come to France. They had, in fact, been in the château. The ensuing trip resulted in a viewing of the albums, but one that was too brief to give any but the most elementary idea of what they contained. Even so, they were of some value in the preparation of the doctoral dissertation that was then in progress. Although the period of time spent looking at the albums was no more than about three hours, certain problems with them immediately became apparent. Not the least of these was the poor state of preservation of many of the photographs.

The Albums as Documents

In keeping a visual record of his artistic output, James Tissot was attempting something with few analogies in earlier art. The first such record that comes to mind readily is Claude Lorrain's *Liber Veritatis*, a book of a hundred and ninety-five drawings done after his paintings that Claude compiled between 1635 and 1682. As the title makes clear, it was intended as a record of the true works of the artist. It would be proof against future forgeries, and it provided the names of the patrons who had acquired the paintings.[3] Another analogy is Joseph Mallord William Turner's *Liber Studiorum*, but here the analogy is less strong than in the case of Claude. Turner's book of ninety-one plates, unfinished at the time of the artist's death, was not intended as a record of his oeuvre. It contains some engravings that are ostensibly reproductions of watercolors and oils, but even in those cases the changes that have taken place in the process of transcription have so altered the designs, as Alexander J. Finberg has pointed out, that they constitute

1

essentially new works of art.[4] In any case, Turner's total artistic output is far greater than the number of works recorded in the *Liber Studiorum*. His intent, then, was even less record keeping than it was an effort to create a book of designs or studies (as the title translates) that would establish for posterity Turner's importance as a landscape artist. It was a work of art in itself at the same time that it was a concise and convenient record that could make the point of Turner's greatness in a way that scattered paintings could not, or at least not so forcefully. In a sense, James Tissot's record-keeping effort combines something of both Claude's and Turner's record-keeping. That is to say, like Claude, Tissot seems to have intended to preserve a record of all or almost all of his painted oeuvre, but his real motivation seems to have been closer to Turner's. Such record-keeping is a self-conscious act, done with an eye to future generations. The artist's fame and renown will be preserved because later generations will know his work as fully as possible. It is a kind of insurance against obscurity, and it implies that the artist fully believes that his art *is worth* being remembered. To be sure, James Tissot did not publish the photographic record of his paintings, but he must have thought that it would survive. In 1886, four years after he showed his photographs in London, he did publish a small book recording his graphic oeuvre. The primary intent of that publication may have been promotional, but it did result in providing a convenient record of most of his prints. Unfortunately, very few copies of it seem to have survived.[5]

The surviving albums, which are reproduced here, are actually very heavy tomes. Some of the photographs are quite large; some are quite small. For the sake of convenience most of the photographs have been reduced. Relatively speaking, the smaller photographs are reproduced here on a larger scale. In some cases the size of reproductions in this publication is determined by page lay-out. Regrettably, a sense of the actual size or dimensions of works is perhaps destroyed, but since the albums give no facts about the works, it is impossible to know how large they are except in the case of works of which the

whereabouts are known. The albums are dated on the spine (except for the last album) with inclusive dates that differ slightly from the dates published in the Dudley Gallery catalogue. The first album is dated 1857-1871 (as opposed to 1859-1870 in the Dudley Gallery catalogue), and the third album is dated 1878-1882 (as opposed to 1876-1882). The initial year on the album shown at the Dudley Gallery indicates the year of Tissot's first exhibition at the Paris Salon. The year 1857 on the extant album probably indicates the year that his activities in Paris began in earnest. He probably arrived in Paris from his home town of Nantes in 1856. The first document placing him in Paris with certainty dates from January of 1857. The middle album is missing, which is unfortunate because it is the album which contains most of the works from Tissot's London period (1871-1882). Presumably it was dated 1871-1878. One explanation for its disappearance is that it was stolen at the sale at the château in 1964. There is another later album which survives and which is also reproduced here. It is a sort of catch-all album, containing mostly works dating after 1882 but also some that really belong in the third album. In this album, there are quite a number of portraits that do not seem to be arranged in correct chronological sequence. Additionally, the photographs of *The Prodigal Son in Modern Life* really belong in the third album, since those paintings were shown at the Dudley Gallery in 1882. Furthermore, the photographs of the *Femme à Paris* series, which was not yet painted in 1882, occur in an album for which the terminal date is 1882.

The albums that are reproduced here are most probably not the albums that were exhibited at the Dudley Gallery in 1882. They seem instead to be an alternate or duplicate set of photographs that were put into albums without the same care and precision that governed the making of the exhibited albums. For this reason, some of the photographs occur out of sequence. These albums are valuable, nevertheless, as the sole record of many lost works. Of the more than three-hundred photographs reproduced here, about one-half are of unlocated works. This fact alone points up the significance of this publication in

bringing a fuller picture of Tissot's oeuvre before the art-loving public and before the art-history profession.

On the other hand, it must be admitted that these photographs or these albums of photographs have a limited usefulness as documents because of their total lack of supplementary information. Nowhere in any of these albums is any vital information given. No title is recorded; no date is given; no dimensions or media are specified. The albums consist simply of photographs glued on album pages, usually one to a page, and presumably more or less in sequence. As noted above, exceptions to this occur in the third and fourth albums. The fact that not even titles are provided in these albums makes it seem improbable that these albums are actually the albums presented for viewing at the Dudley Gallery. It is hard to imagine an artist as systematic as Tissot offering the public a pictorial record of his oeuvre and at the same time giving them absolutely no information about what they were seeing.

The albums reproduced here begin with the five works shown in Tissot's first Paris Salon exhibition, the Salon of 1859, but these works are not arranged in the order in which they are listed in the Salon catalogue. Still, they may be arranged in the order in which they were actually done. Generally speaking, Salon paintings seem to be clustered together in groups, and from this it seems possible to adduce identifications for previously unknown Salon entries. Exceptions would be the watercolor version of *Mélancolie* from the Salon of 1868 (the oil version is recorded in the album), and the pastel portrait from the same Salon. Neither is recorded in the first album. Additionally, the illustration numbered I-16 in the present publication seems, from its location in the album, to be identifiable as *Portrait de Mlle M...P...* from the Salon of 1861. The presence, however, of what seems to be a wedding ring on the third finger of the left hand of the sitter seems to indicate that this is not a portrait of an unmarried woman.[6] Nevertheless, the fact remains that nowhere in the first album is there a portrait that fits so closely descriptions of the *Portrait de Mlle M...P...* that are given in contemporary reviews.

The simple explanation of the ring may be that despite its location it is just not a wedding band.

Even though this *recueil* of Tissot's work is incomplete and does not show the "complete collection" of the artist's works as advertised in the Dudley Gallery catalogue, it is still valuable in rounding out the picture of Tissot's oeuvre. This publication of these documents illustrates for the first time many lost works from Tissot's crucial first decade in Paris, a decade in which he was finding his way as an artist. Previously unknown as a still-life painter, Tissot is revealed here as a painter of charming still-lifes, although these are few in number. This collection of photographs also suggests something of Tissot's activities as a portraitist and pastellist after his return to Paris from London in 1882. Recorded here also are five oil versions of Old Testament subjects, related to but differing from the Bible illustrations on which Tissot was working at the time of his death in 1902. These are variant versions of some of the small gouaches that were used to illustrate the Old Testament in the grand publishing scheme that was realized in 1904. No doubt Tissot thought it was not necessary to record in his albums the more than seven-hundred paintings illustrating both the Old and the New Testaments, since these were reproduced in any case in the books printed for popular distribution. Tissot's will lists five oil versions of New Testament subjects (not including the painting of the Three Kings that is in the Minneapolis Institute of Arts), and none of these is recorded in the albums.

Some omissions from this pictorial record are noted above; there are doubtless others as well. The albums here reproduced do not provide a complete record of Tissot's oeuvre. They do provide, however, the most comprehensive view of his artistic output yet available. For the most part, where watercolor versions of oil paintings were done they were not recorded in these albums. *The Prodigal Son in Modern Life* is a case in point. Notably absent also are two paintings that Knoedler's had in the 1940s, *In the Conservatory* and *The Young Botanists*. Ostensibly paintings of the early 1860s, these stylistically-suspect paintings are not recorded in the albums in a period when the record seems to be most nearly

complete. On the other hand, in the recent past several unquestionable Tissots that are not recorded in the albums have appeared on the art market.

This publication

The principal aim of this presentation of the albums that survive is to publish, and thus to preserve, important visual documents that are rapidly deteriorating. These are the photographs in the albums. Thus, this is a publication of the documents and not of the art recorded by the documents. Therefore, there has been no attempt to catalogue the works themselves, which would entail providing such vital statistics as medium, mount, dimensions, provenance, and a commentary on each work. This is a separate undertaking, which is currently under way. While the works presented and recorded here do not provide a complete record of Tissot's oeuvre, they are essential to a full view of his work, and no publication that does not take them into account can pretend to completeness.

Because this publication is intended primarily as a preservation of documents as they exist there has been no attempt to replace the old, fading photographs with more recent, better quality photographs where they were available. Neither has there been any retouching or enhancement of photographs, even in those cases where it is obviously desirable and eminently feasible. Even in the case where there are two reproductions (I-81 and I-82) that are not original photographs but are reproductions that have obviously been stuck in at the end of the first album on conveniently empty pages, these have been retained in their original place in the album though they are not even from the period covered by the album.

There are no titles given in the original albums. In this publication, editorial prerogative has been exercised to provide them for the convenience of the reader. In cases where the exact title is not known, a provisional identification such as "Unidentified medieval subject" or "Portrait of an unidentified gentleman" has been supplied. These provisional titles are further distinguished from the bona fide titles by not being set in italics. In some cases, titles not given by Tissot but

sanctioned by general usage have been preserved. There is an additional problem with Tissot's titles in that he sometimes changed the titles of his paintings from exhibition to exhibition. The numbering system adopted for this publication refers to the album in which the photograph is found and to the photograph's order in that album. Thus, for example, photograph I-6 would be the sixth photograph in the first album, with the Roman numeral signifying the album and the arabic numeral signifying the photograph itself. The designation III-15 would signify the fifteenth photograph in the third album. Roman numeral II is not used, being reserved for the second album, which is missing. Dates that are given here are generally the dates of the first exhibition of works. In some cases, a date that is legible in the photograph is given. This results occasionally in a painting's seeming to be a year or two out of chronological sequence, but this is the least true of the first album where chronological order seems to be preserved most scrupulously. The exact order of portraits in the last or fourth album is uncertain, but, in any case, they are not arranged in precise chronological sequence in the album. Additionally, even though this is not a catalogue of the paintings and catalogue entries have not been provided, a brief check-list of locations, where generally known, is provided at the back of the volume.

As stated above, the main intent of this publication is to preserve important visual documents before deterioration renders them worthless. One of the hoped-for results of this publication is that it will add enough fire to the reviving interest in Tissot that many of the missing works can be located and given their correct titles. Numerous sitters in the portraits remain to be identified. Perhaps this publication will bring forth the present owners of many of the protraits, who will be able to provide identifications of family members, as in the case of the Miramon family protraits. It is even possible that the appearance of this volume will generate enough interest to bring to light the lost-lost second album, thus filling in an important gap and making possible a reasonably thorough catalogue raisonné of Tissot's paintings. Since the albums reproduced

4

here do not seem to be the actual Dudley Gallery albums of 1882, it is even possible that this publication will elicit another set of albums which will help to clear up all the problems outlined above.

James Tissot's First Salon

James Tissot made his debut at the Paris Salon in 1859. It was actually a rather humble beginning for what was to become one of the publicly most successful careers in later nineteenth-century French painting. Of the five paintings that Tissot showed in this Salon, only one is located today. It is in a private collection in Paris. The only visual documentation of the other four paintings is to be found in the albums. This is unfortunate, because in some ways James Tissot's first Salon is a foretokening of much of his subsequent career.

Promenade dans la neige, the one painting for this Salon of which the location is known, is the first announcement of Tissot's penchant for medieval subjects, something which he does not abandon until 1868. It also announces his interest in costume. Even though the specific type of costume may vary in his paintings, from medieval to oriental to Directoire to modern, costume is always uppermost in his mind. It is this aspect of his interests that has made his work a favorite source of illustrations for authors of books on costumes. *Promenade dans la neige* also looks forward thematically to Tissot's frequent use of the idea of tension between lovers. Unfortunately, the most exquisite realization of this theme in paint, *Quarrelling* (an etched version of which was shown at the Royal Academy in 1876) falls in the period recorded in the missing album, so it cannot be seen here. *Promenade dans la neige* is an avowal in his first Salon of his admiration for the work of the Belgian painter Baron Hendrik Leys, although this painting is not as Leysian as some of his later paintings, such as *Retour de l'enfant prodigue* of the Salon of 1863.

The two portraits from Tissot's first Salon, *Portrait de Mme T...* and *Portrait de Mlle H... de S...* look forward to his future importance as a portraitist. The portrait of his mother is the only image of her known to exist, and even it cannot be located in the Tissot family.[7] The exhibition of a portrait of his mother in the first Salon says something about Tissot's devotion to his family, something that is borne out again and again in later years. Unfortunately, the sitter for the *Portrait de Mlle H... de S...* cannot be identified with certainty.

Of particular interest concerning the albums as documents relating to Tissot's first Salon is the preservation of the only photographs of the two paintings which depict two saints each, *Saint Jacques-le-Majeur et Saint Bernard* and *Saint Marcel et Saint Olivier.* These paintings were done in *peinture à la cire,* a technique used by one of his teachers, Louis Lamothe. In format and in composition they recall the paintings of saints and patriarchs that his other teacher, Hippolyte Flandrin, was doing at the time in the Church of Saint Germain-des-Prés. These two lost paintings by Tissot are reproduced here for the first time. Ostensibly they were designs for stained glass windows in memory of the artist's parents, and, according to Bénézit (*Dictionnaire des Peintres, Sculpteurs, Dessinateurs et Graveurs*, revised edition, Librairie Gründ, 1976) they were intended for a church in Nantes, the city of James Tissot's birth. In 1845 Tissot's parents acquired the Château de Buillon, in his father's native region of France, not far from Besançon. It stands on the grounds of a ruined Cistercian abbey, destroyed during the French Revolution. Madame Tissot retained her hat-making business in Nantes until her death in 1861, and the elder Tissots could have kept a residence there as well. Thus, it makes sense that the projected windows could have been meant for a church in Nantes. The Tissots' parish church at this time in Nantes would have been the Church of Saint-Nicolas. It is doubtful that the windows were ever done, and, in any case, if they had been done for this church they would have been destroyed in the Second World War along with all the rest of the windows in the church.

James Laver, in *Vulgar Society: The Romantic Career of James Tissot* (Constable, 1936), supposed that the windows were to be in memory of James Tissot's mother, but she was not yet dead. The projected windows do relate, however, to Marie Durand Tissot's family, and they may even have been intended for the chapel that she had built on the château

grounds in 1848 to replace a rickety one that was in danger of collapsing. This chapel now contains her tomb and that of her artist-son. Three of the four saints selected for representation are the name saints of the four males in Madame Tissot's immediate family— her husband Marcel and her son Marcel, and her sons Jacques (James) and Olivier. Her fourth son, Albert François, had died in 1840. There was no Bernard in the Tissot family. The fourth saint is Saint Bernard of Clairvaux, who joined the Cistercian order in 1112, fourteen years after it had been founded by Robert de Molesme at Cîteaux. Saint Bernard was active in founding Cistercian monasteries and in 1135 was present at the Abbaye de Buillon for the consecration of the monastery church. In Tissot's painting of him, instead of having one of his usual attributes, he holds a small chapel which resembles very closely Madame Tissot's chapel at Buillon, with the exception that it has three windows on a side instead of the two on a side that the actual chapel has. The windows in the chapel are not the right proportion to have held windows such as those that James Tissot designed. Thus, whether Tissot's window designs were intended as windows for this chapel is perhaps a question that cannot be resolved. Their purpose as family documents, however, is quite clear.[8]

Saint James the Greater is given his traditional attributes of pilgrimage—a scallop shell, a pilgrim's staff, and a gourd. Interestingly, at the end of his volumes of illustrations of *The Life of Christ* thirty-seven years later, Tissot was to include a self-portrait in which he is surrounded by funeral accoutrements. He called it *Portrait of Pilgrim*. It is worth observing also that as the illustrator of the Old and New Testaments late in his life, after a very successful and very worldly career, James Tissot returned, in a very impressive way, to the pious interests that were announced in these two paintings of four saints from his first Salon.

The Serial Paintings

One advantage of the *recueil* of Tissot's work that is presented here, incomplete though it may be, is that one can get a fuller overview of the artist's work than is currently available in any other single source. As a result, it is possible to see, through an examination of these visual documents, at what stages in his career and to what degree the notion of doing paintings in coordinated groupings or in series had an appeal to him. The first such grouping is the Faust and Marguerite series, a group of eight paintings done between 1859 and 1861. These begin with a previously unknown painting of a pensive Marguerite standing in a spiral staircase, which is, in fact, the staircase of the abbatiale at Buillon. It is also the first painting in which Tissot displays an interest in finely detailed medieval costume in the manner of Baron Leys. The lady's costume in *Promenade dans la neige*, one of Tissot's first Salon paintings, is not nearly so detailed, for example. Six of the eight paintings in the group are devoted to Marguerite alone, in agonized self-torment. While the paintings revolve around a single story, albeit not following Goethe's version of the tale very closely, they do not reveal a narrative progression. They may, in fact, not even depend on Goethe but on some other version of the tale. Nevertheless, even though they have a source in literature, they do not convey a sense of literary development and denouement.

As paintings of historical fashion the paintings of Marguerite are interesting forerunners of Tissot's later paintings in which ladies' fashions are featured. His *Portrait de Mlle L... L...* of 1864 is the first painting of a full-length female figure in which fashion seems to vie with concerns of portraiture. By looking back three years one can see that Tissot has given the sitter for this portrait the same pose that he gave Marguerite in his third depiction of her, *Marguerite à l'office* of 1861. He derived this pose, in turn, from the seated figure of a woman in a Leys painting, *Martin Luther Singing in the Streets of Eisenach*, which is in the Detroit Institute of Arts.[9] Moreover, Leys had done an etching after the painting of only this seated female figure. This etching was sometimes called *Marguerite à l'église*. Since in the etching this woman is in the opposite direction from the figure in Leys's painting, this etching is most likely Tissot's immediate model. Thus it can be seen that when Tissot begins his move away from the medievalism that was

inspired by Leys it is through a paraphrase of his own Marguerite, which is in turn a paraphrase of Leys's Marguerite. The *Portrait de Mlle L... L...* heralds Tissot's preoccupation with elegant women in fine garments that is to be seen in numerous paintings that echo the conventions of the contemporary fashion plate. This preoccupation can be traced throughout the first album. When one turns to the third album one sees the logical culmination of both the use of the fashion-plate convention and the concern with contemporary subjects, that is, modernism, in the grandiose *Femme à Paris* series. Thus, in a sense, Marguerite and Mlle L... L... are really foreshadowings of Tissot's series on modern woman—the woman of Paris.

The missing album (1871-1878), while it must record a large number of the delightful anecdotal paintings that Tissot did during his London period, most likely does not contain any photographs of serial paintings. The notable exception would be *The Challenge*, the only finished painting from a projected didactic series called *The Triumph of Will*. This painting is presumably recorded in a photograph in the missing album. It was shown at the Grosvenor Gallery in 1877 and is now in a private collection in France. Perhaps it was this miscarried attempt at some rather pompous moralizing that prompted Tissot to paint *The Prodigal Son in Modern Life* series in which, for the first time, a real narrative unfolds. This series, recorded out of sequence in the fourth album, was shown at Tissot's "Exhibition of Modern Art" at the Dudley Gallery in 1882, the same exhibition at which the albums of photographs were shown. The full significance of this series has yet to be satisfactorily explained. If one takes note, however, of the third painting in the series, *The Return*, and compares it with the illustration for this parable in the New Testament series, one sees the same father-son figure grouping used in both paintings. Thus, like the slightly later *Femme à Paris* series, this series figures in Tissot's practice of borrowing from his own works.

A group of paintings with a common theme, executed by Tissot shortly after his return to Paris, is the set of nine unlocated paintings of potted plants of which photographs are preserved in the last album. The paintings,

called *Le Jardin des Hespérides*, were done as decorative panels for the dining room of Mr. Henry Oppenheim in London. They were shown at the Palais de l'Industrie in 1883. Since their purpose was purely or primarily decorative, they were not intended to convey any narrative, but, considering the plants selected to represent this ideal garden, it is possible that the panels had symbolic overtones. How else can one explain the inclusion of a thistle in an idyllic garden? With the exceptions of the tuberose and the oleander, all of the plants depicted have symbolic significance in the iconography of art. A significant omission from the plants chosen to represent the Garden of the Hespérides is the apple tree, the most important plant in the garden. Perhaps in this series the orange tree substitutes for the tree of the golden apples of the Hespérides just as it is occasionally used, instead of the apple tree, to signify the fruit associated with the fall of man.

As regards Tissot's serial paintings, the most valuable documentation is to be found in the third album, where are preserved photographs of fourteen of the fifteen paintings in the *Femme à Paris* series along with photographs of two or possibly three paintings from a second series on modern woman, *L'Étrangère* or foreign woman. These two series depict modern Parisian woman at her various occupations and diversions. They consist of separate, unrelated incidents and they completely lack narrative progression. That is, it does not matter in what order the paintings are seen. This is pointed up by the fact that paintings from the second series, *L'Étrangère*, are mixed in with the *Femme à Paris* paintings, or photographs of them, in the album in which they occur. It was with these series, one complete and one partial, that Tissot hoped to re-establish himself in the Paris art world when he showed them in 1885, two and a half years after his return from an eleven-year absence in London.

It is not the purpose of this essay, however, to analyze the iconography of these series or other relevant concerns, such as the literary affinities of the *Femme à Paris* series.[10] One can note, however, through examining the photographs that are here recorded, the pivotal position of the *Femme à Paris* series in Tissot's

oeuvre.[11] A number of the paintings restate themes and motifs and compositional elements that the artist had used in his earlier works. For example, the general theme of *Une Veuve* (1868)—two ladies waiting in a park in the hope of relieving the single state of the younger—is revived in *Sans Dot* of the series; and the old lady reading in the later painting is almost a direct quotation from the earlier painting. Two comparisons that, unfortunately, cannot be made visually because key photographs are contained in the missing album, would show even stronger links between *Femme à Paris* paintings and earlier works. *L'Ambitieuse* from the series depends very heavily on *Evening*, which was shown at the Grosvenor Gallery in 1878. The latter painting is now owned by the Louvre and is destined for the Musée d'Orsay when that museum opens in the near future. In *Les Demoiselles de Province* Tissot has used the figure grouping of a father and his three daughters from *Too Early* (The Guildhall Art Gallery, London), which was shown at the Royal Academy in 1873. The later painting reverses the grouping and updates the ladies' fashions. *La Voyageuse* from the *Étrangère* series, the unfinished series on foreign woman, depends rather loosely on *Emigrants*, which was shown at the Grosvenor Gallery in 1879.

Unfortunately, the photograph of *La Musique sacrée* from the *Femme à Paris* series has been removed from the album it should be in. Its absence is all the more regrettable since the painting is unlocated and no other photograph of it is known to exist. It was while working on studies for this painting in the Church of Saint-Sulpice that, Tissot claimed, he experienced a mystical vision which led to his painting *Christ le consolateur* and to his religious reconversion, which led to his devoting the rest of his life to illustrating the Old and New Testaments. Given Tissot's penchant for quoting from his earlier works, as seen in other paintings in the *Femme à Paris* series, it is entirely probable that *La Musique sacrée* strongly resembled *Jeune femme chantante à l'orgue* from the Salon of 1867. In the earlier painting the nuns wear the habit of the Retraite d'Angers, and the setting is clearly identifiable as the Church of Saint-Gervais in Paris although Tissot has changed the *buffet de l'orgue*, either inventing one of his own or substituting one from another church.

It is unfortunate that the album that contains the majority of Tissot's London period paintings is missing. Were it possible to present it here as well the reader could see more easily how some of the viewer involvement devices that the artist uses in the *Femma à Paris* series—proximity of the action or the motif to the viewer, for instance, or glances or gestures which invite the viewer into the painting—begin to develop in the London period paintings and are, in turn, carried over into their logical realization in the late religious series paintings. For instance, the horse and carriage slowly moving toward the viewer in *Going to Business* (1879) are transformed in *Ces Dames des Chars* into a rapidly moving ensemble that passes only inches in front of him. This device is echoed in *Ahab Pierced by an Arrow* from the Old Testament series. The most insistent attempt to draw the viewer into one of the *Femme à Paris* paintings is found in *La Demoiselle de magasin* in which the young shop girl smilingly invites the viewer, who is her customer, into her space to hand him his purchase and to usher him into the space of the street beyond. In a somewhat different manner this idea of placing the viewer at the center of the action is carried to its most surprising but, at the same time, it most logical realization in one of the New Testament paintings, *What Our Savior Saw from the Cross*, in which it is implied that the viewer is in the position of Christ on the cross, looking down at the crowd below.

With the exception, noted above, of a few photographs in the last album which record oil versions of some of the Old Testament illustrations done in gouache, Tissot's two most important series are not recorded in these albums. These are the New Testament series, which consists of three-hundred and sixty-five small scale paintings in gouache, and the Old Testament series, which consists of three-hundred and seventy-three illustrations in gouache. The first series is in the Brooklyn Museum and the latter series is in the Jewish Museum in New York City. It was on the latter series that Tissot was working when he died at the Château de Buillon in 1902. It was in part

the financial success that these series brought him that enabled Tissot to turn the chateau and its grounds into a grand country estate. Practically speaking, there was no need to record these two enormous series in photograph albums since they were recorded by being published in the large volumes that were available to the public in various editions. Although these series were supposedly motivated mainly by an exemplary piety, their production and publication were also a very clever commercial venture. It is this venture that Tissot seems to have counted on to ensure his fame with his public and with posterity. Similarly, for the earlier part of his career, it was the creation of albums of photographs recording his oeuvre that would serve to bring his works together in a single place and guard against obscurity.

James Tissot and Photography

One of the most significant things to note as regards James Tissot's photographic record of his painted oeuvre is how early it begins in relationship to the development of photography itself. The earliest photographic images in the albums are those of the paintings from Tissot's first Salon, the Salon of 1859. This is only twenty years after the invention of the daguerreotype was announced in January 1839. This early photographic process was supplanted in 1848 by the albumen process which dominated until the late 1850s, that is, until about the time that Tissot began recording his art work. It was probably the collodion process, however, introduced in March 1851, that was used for Tissot's photographic record of his paintings. In any case, by the time Tissot arrived in Paris in 1856 the photography industry, although still relatively young, had experienced tremendous growth, and by 1861 there were 33,000 people in Paris who made their living from photography and allied trades.[12] Two photographic societies had been founded in Paris, one in 1851 and one in 1854, and both were publishing journals. Thus, the young artist from Nantes had arrived in a city in which photography was very much in the air, and he seems to have realized immediately its usefulness for him. The photographic record that he kept of his own work must surely be one

of the earliest such records, if not the earliest, made by an artist.

Whether or not Tissot himself took the photographs of his own works is a moot question. There were certainly plenty of opportunities for him to learn the requisite skills in the Paris of the 1850s. There is little reason to doubt that in later years he was quite active as a photographer. For instance, there are literally dozens of extant photographs that record the château and its grounds and the life that went on there in the 1890s. According to Lilian Hervey, the niece of Kathleen Newton, Tissot's mistress during his London period, he used a studio assistant with photographic skills to help record the groupings of models he posed for paintings he planned to do.[13] It is equally probable that he did most such photography himself. It is also probable that Tissot made liberal use of the camera during his trips to the Holy Land when he made studies for his Old and New Testament illustrations although seemingly no such photographs have survived. In the abbatiale at the Château de Buillon he did have complete photographic facilities, and he probably put them to use for more than just indulging in amateur photography of his home, his family and his visitors.

Even though he may have learned photography early on in Paris, Tissot does not seem to have used it as a compositional aid at that time. According to Gernsheim, Charles Nègre, a pupil of the photography teacher Gustave Le Gray in 1851, made photographs of genre subjects to use as studies for his Salon paintings. In the 1850s Courbet and Delacroix used photographs as compositional aids, as Van Deren Coke has pointed out.[14] If Tissot did the same thing in the 1850s and 1860s, no photographs proving it have survived. The photographs on which Tissot based paintings during his London period and have survived were all preserved by Lilian Hervey, who gave them to Marita Ross. They have been used to illustrate Miss Ross's article, "The Truth About Tissot," and as illustrations in catalogues for the Tissot retrospective exhibition (Providence and Toronto, 1968) and for the exhibition of Tissot's prints (Williamstown and Minneapolis, 1978). Photographs in the albums that record works that are demonstrably based on these

posed photographs include those of *La soeur aînée, En plein soleil, Waiting for the Ferry*[15] and the painting of a group of people at Richmond Bridge. These are recorded in the third album. Additionally, the last two paintings recorded in the fourth album—a self-portrait painted on silk and an oil painting of the château and its dependencies—are based on extant photographs. The number of surviving photographs that Tissot used as paintings aids is very small. There must have been a great many more.

Tissot's approach to the art of painting is a realist's approach. His realist's eye early showed him the uses to which the new science of photography could be put. In a day when no great stigma was attached to painting very representationally, Tissot used the camera to sharpen his realist's skills and to create paintings that were truthful recordings of his world. Even earlier than that, however, he realized the value of the camera in preserving for himself and for posterity a record of his painted oeuvre which would necessarily be dispersed if he were to achieve fame as an artist. It is this aspect of Tissot's endeavors that the albums record and which lends them their historical value.

Notes

[1]Modern scholarship on Tissot has produced two monographic studies done as doctoral dissertations. The first one was by the present author and was done in 1971 for Washington University. In 1976 Harvard University accepted a second such study. Its author is Michael J. Wentworth.

[2]David S. Brooke, Michael Wentworth, and Henri Zerner, *James Jacques Joseph Tissot: A Retrospective Exhibition.* Providence and Toronto, 1968.

[3]Michael Kitson, *Claude Lorrain / Liber Veritatis.* London: British Museum Publications, 1978.

[4]Alexander J. Finberg, *The History of Turner's Liber Studiorum.* London: Ernest Benn Limited, 1924.

[5]The three copies known to the present author, besides his own, are in the Frick Library, the Bibliothèque Doucet, and a private collection in France.

[6]Using the ring as an argument, Michael Wentworth, in his dissertation, challenges this identification but without saying that such an identification had ever been made. The identification was first proposed by the present author in his dissertation on Tissot.

[7]The only likeness of Tissot's father known to the present author is a marble bust in a private collection in France. It was made by Armand-Pierre Harel in 1877.

[8]This original interpretation of the window designs, based on research into the Tissot family and on visits to the château, is to be found first in the present author's dissertation. Essentially the same interpretation is offered five years later in Wentworth's dissertation.

[9]This observation was made by Michael Wentworth in a lecture at the Jewish Museum in New York on March 28, 1982. It was earlier made by the present author in a public lecture at the Minneapolis Institute of Arts on June 25, 1978.

[10]The first discussion of the literary affinities of the series is to be found in the dissertation of the present author, to whom the discovery must be credited.

[11]This was first developed in the present author's dissertation and later expanded in a talk at the annual meeting of the College Art Association in New York in 1978.

[12]The source for the information about photography in this section is *The History of Photography* by Helmut and Alison Gernsheim (London: Thames and Hudson, 1969).

[13]Marita Ross, "The Truth About Tissot," *Everybody's Weekly,* June 15, 1946.

[14]Van Deren Coke, *The Painter and the Photograph.* Albuquerque: University of New Mexico Press, 1972.

[15]Coke credits Henri Zerner with pointing out the relationship between this painting and a photograph when he should credit David Brooke. In fact, it was the present author who pointed out the relationship to Mr. Brooke in London in July, 1967.

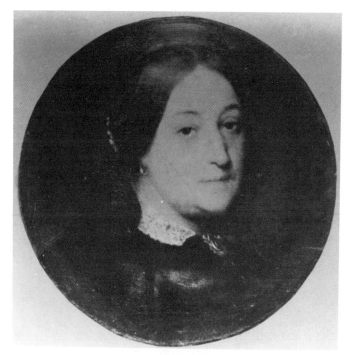

I-1: *Portrait de Mme T...*
(Marie Durand Tissot, the artist's mother), 1859

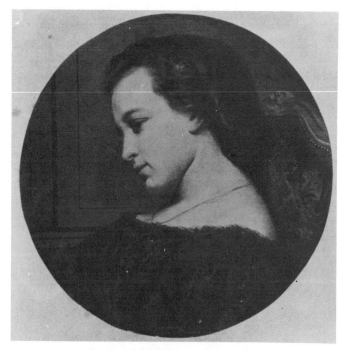

I-2: *Portrait de Mlle H... de S...*, 1859

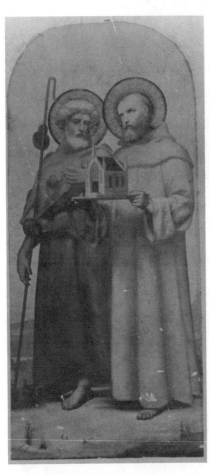

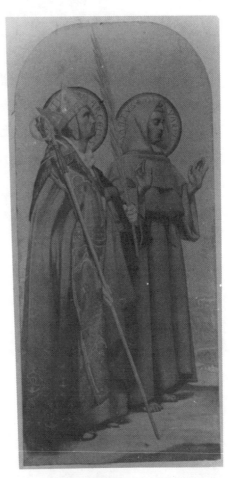

I-3: *Saint Jacques-le-Majeur et
Saint Bernard, 1859*

I-4: *Saint Marcel et Saint Olivier,
1859*

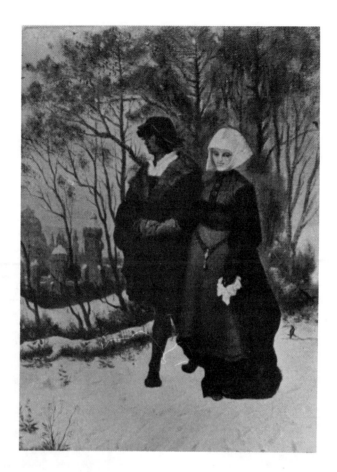

I:5 *Promenade dans la Neige,*
1858

I-6: Woman before a screen

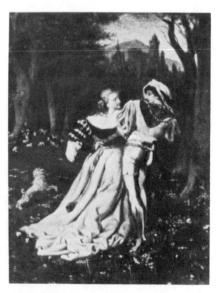

I-7: Unidentified fifteenth-century subject

14

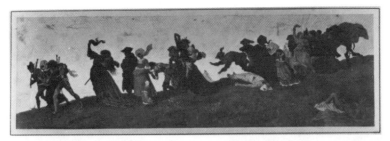

I-8: *Voie des fleurs, voie des pleurs,*
1859

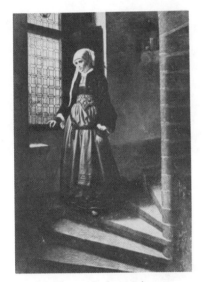

I-9: Marguerite in a staircase
(the staircase of the abbatiale at Buillon)

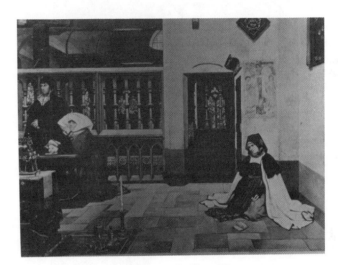

I-10: *Pendant l' office,* 1861

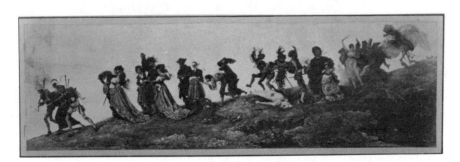

I-11: *Voie des fleurs, voie des pleurs,*
1861

15

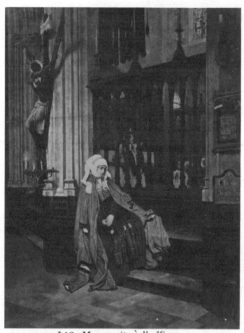

I-12: *Marguerite à l' office,*
1861

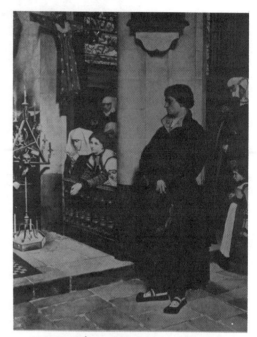

I-13: *Les Vêpres (Martin Luther's Doubts),*
1860

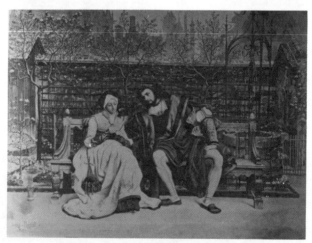

I-14: *Faust et Marguerite au jardin,*
1861

16

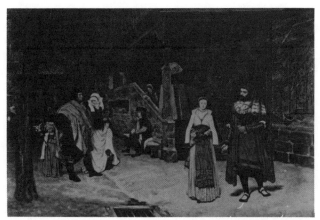

I-15: *Rencontre de Faust et de Marguerite,*
1860

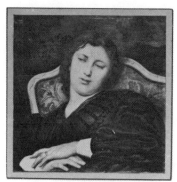

I-16: *Portrait de Mlle M...*
P... (?), 1860

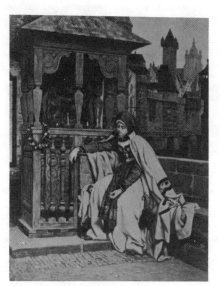

I-17: *Marguerite au rempart,*
1860

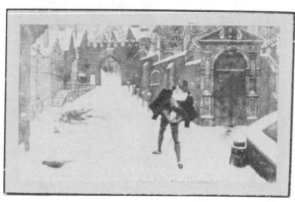

I-18: *At the Break of Day*

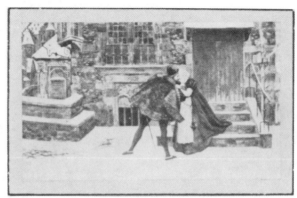

I-19: *The Elopement*

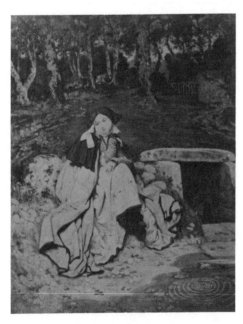

I-20: *Marguerite à la fontaine,*
1861

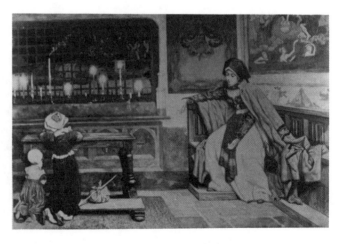

I-21: *Marguerite in Church*

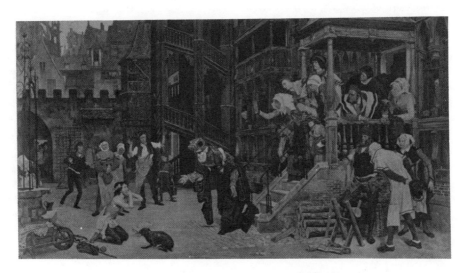

I-22: *Retour de l' enfant prodigue,*
1863

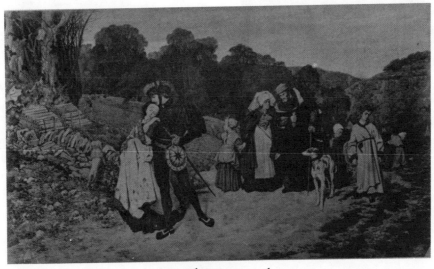

I-23: *Départ du finance,*
1862

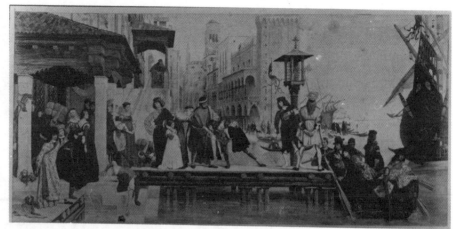

I-24: *Le Départ,* 1862

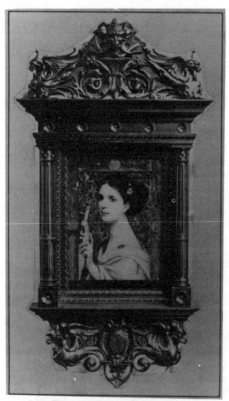

I-25: Portrait of an unidentified lady

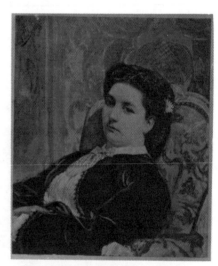

I-26: Portrait of an unidentified lady,
1863

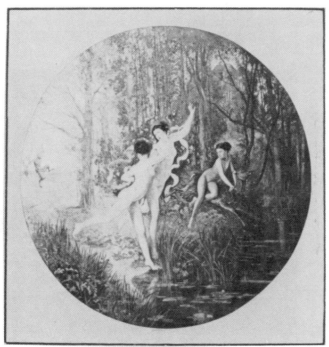

I-27: Nymphs and satyr

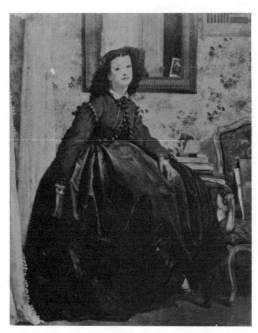

I-28: *Portrait de Mlle L... L...*, 1864

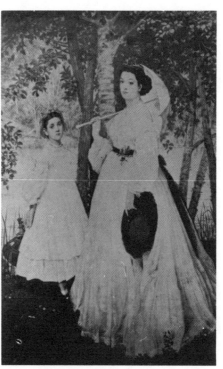

I-29: *Les deux soeurs*, 1864

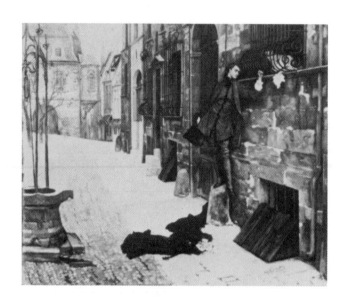

I-30: Unidentified eighteenth-century subject

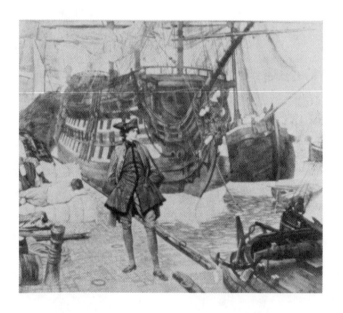

I-31: Unidentified eighteenth-century subject

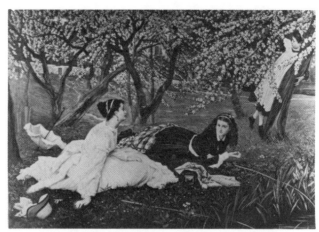

I-32: *Le printemps*, 1865

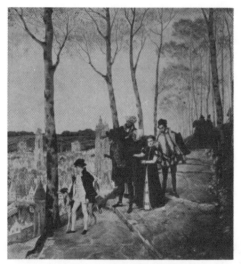

I-33: *Promenade sur les remparts*, 1864

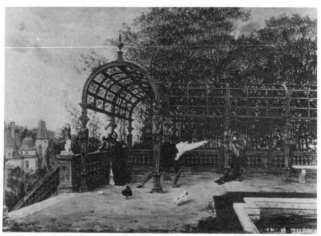

I-34: *Tentative d' enlèvement*, 1865

23

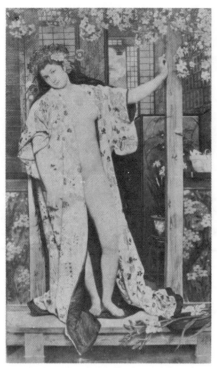

I-35: *Japonaise au bain*

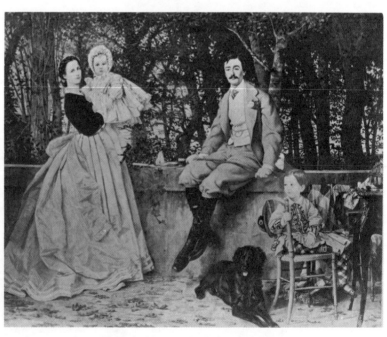

I-36: *Le Marquis de M... et sa famille*
(Marquis de Miramon and family), 1865

24

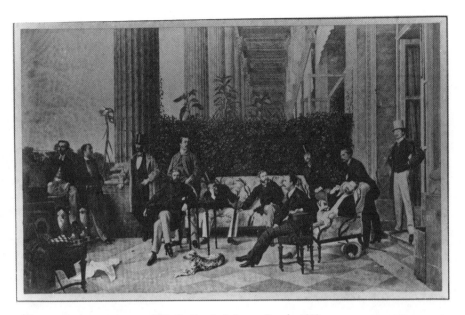

I-37: *Le Cercle de la rue Royale,* 1868

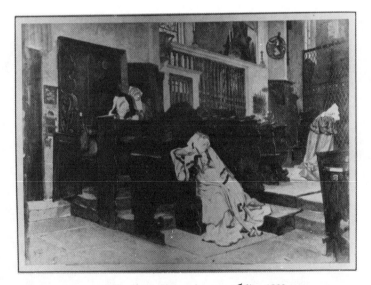

I-38: *Jeune femme dans une église,* 1866

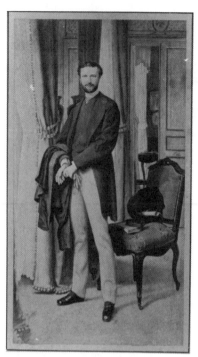

I-39: Portrait of an
unidentified gentleman

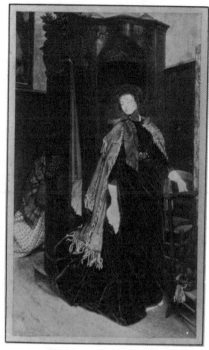

I-40: *Le confessional*, 1866

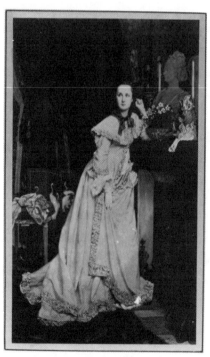

I-41: *Portrait of the
Marquise de Miramon*, 1865

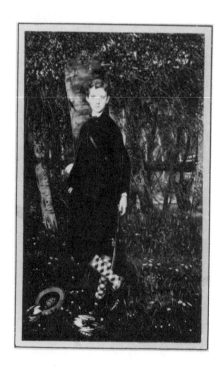

I-42: Portrait of an unidentified boy

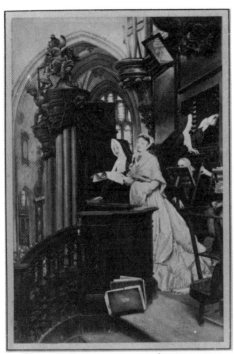

I-43: *Jeune femme chantante à l' orgue*, 1867

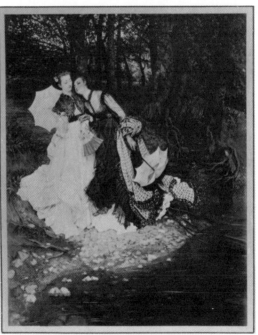

I-44: *Confidence (L'Aveu)*, 1867

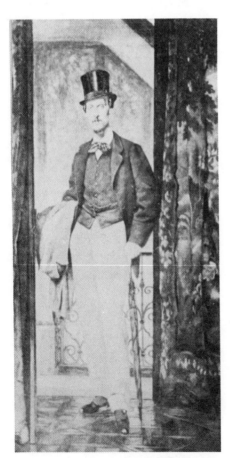

I-45: Portrait of an unidentified gentleman

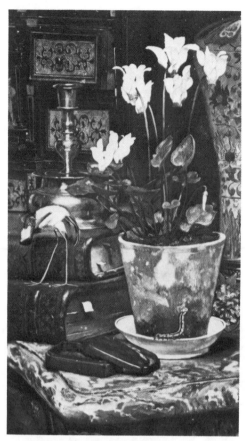

I-46: Still-life with cyclamen

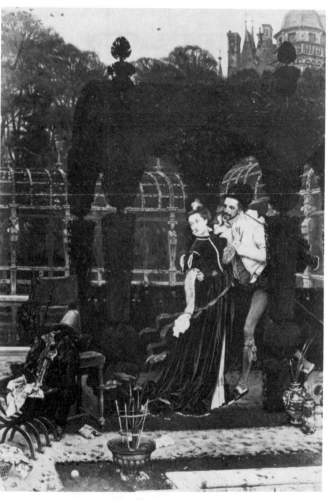

I-47: *Le Rendez-vous*

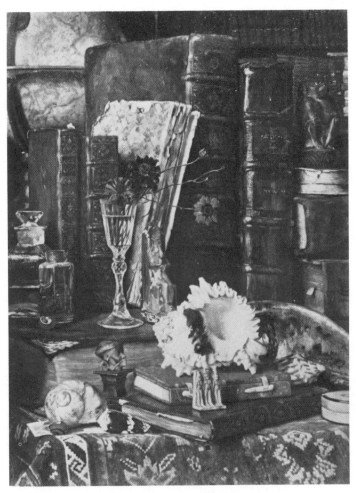

I-48: Still-life with shells, 1866

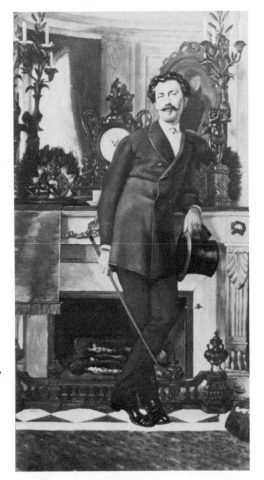

I-49: *Eugène Coppens de Fontenay,* 1867

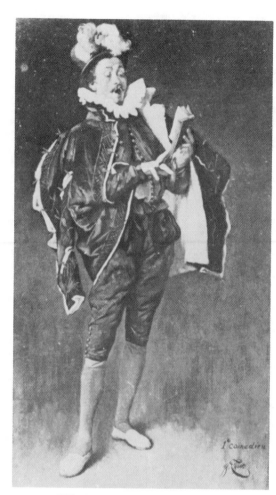

I-50: *Premier comédien*, 1867-68

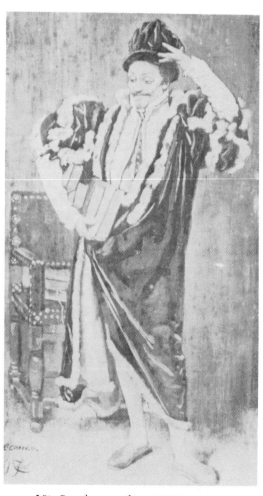

I-51: *Deuxième comédien*, 1867-68

30

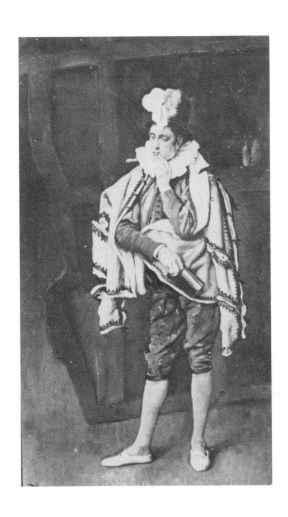

I-52: *Troisième comédien*, 1867-68

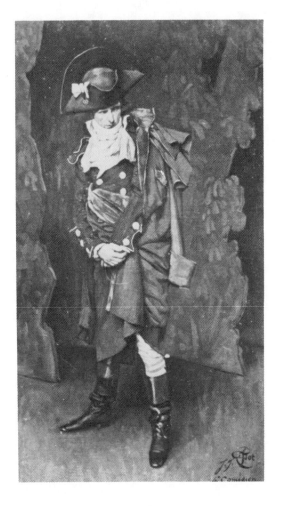

I-53: *Quatrième comédien*, 1867-68

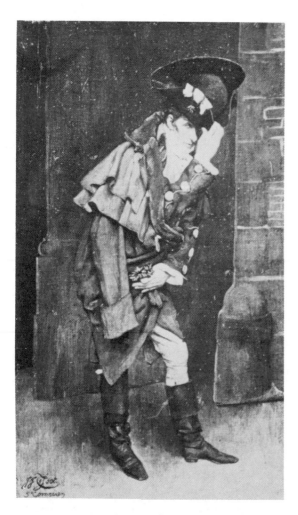

I-54: *Clinquième comédien*, 1867-68

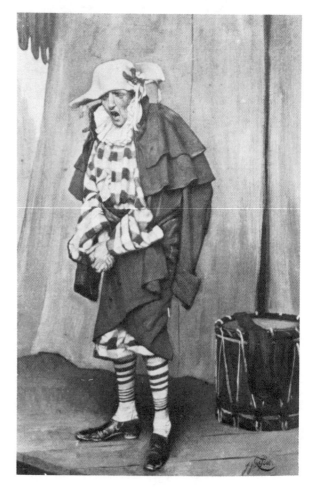

I-55: *Sixième comédien*, 1867-68

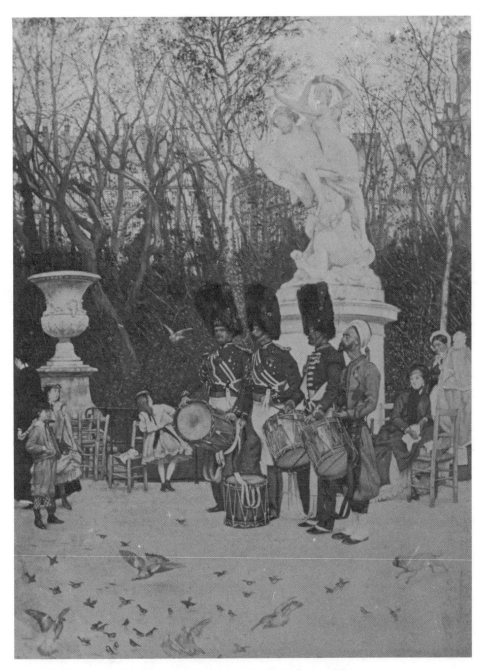

I-56: *La retraite dans le jardin des Tuileries*, 1868

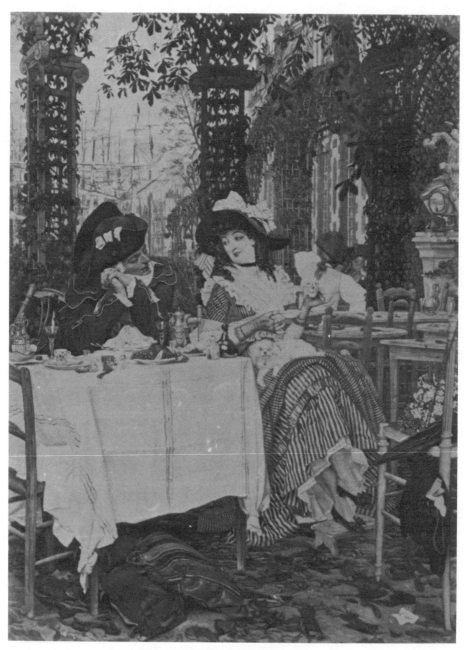

I-57: *Un déjeuner*, 1868

34

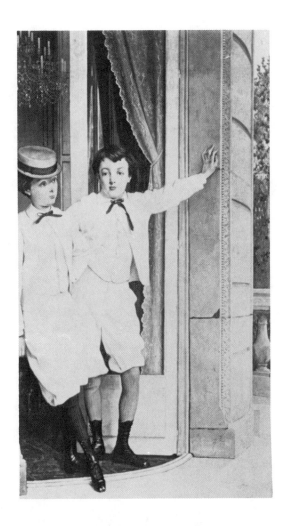

I-58: Portrait of unidentified children

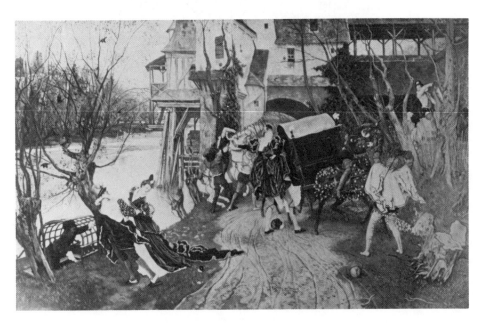

I-59: Unidentified sixteenth-century subject

35

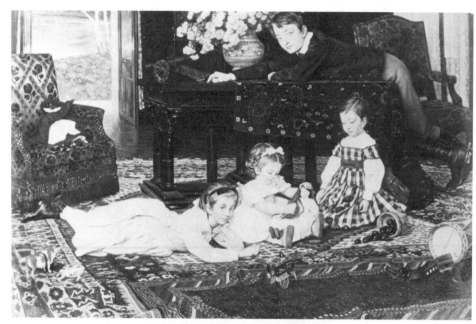

I-60: Portrait of four unidentified children

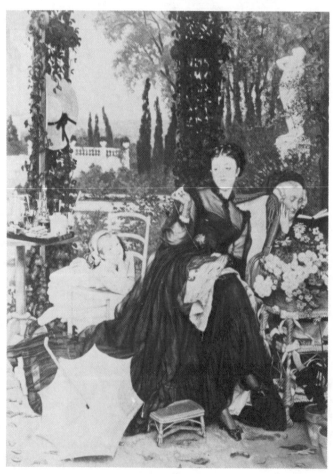

I-61: *Une veuve*, 1868

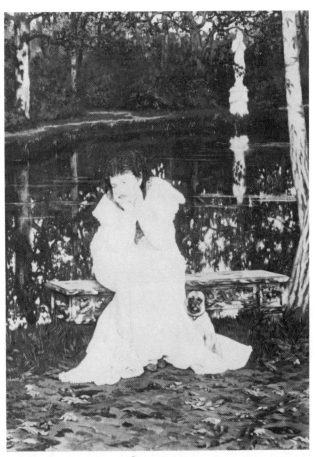

I-62: *Mélancolie,* 1869

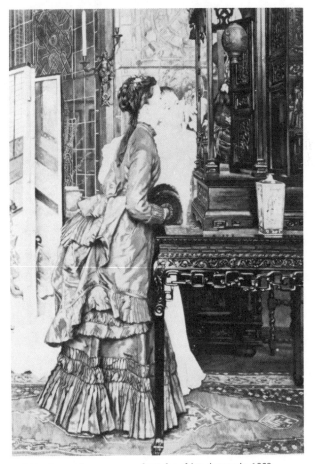

I-63: *Jeunes femmes regardant des objets japonais,* 1869

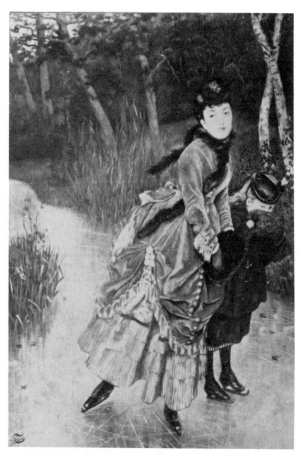

I-64: *Les patineuses*, 1869

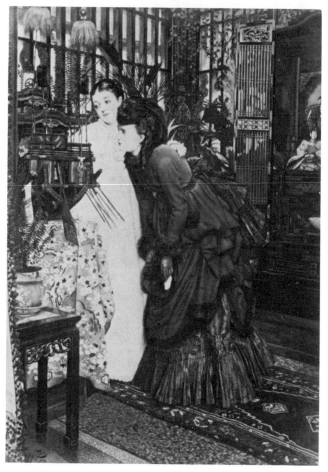

I-65: *Jeunes femmes regardant des objets japonais*, 1869

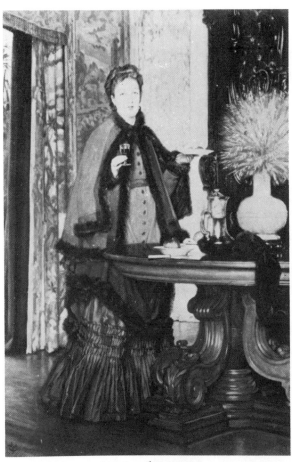

I-66: *Le goûter,* 1869

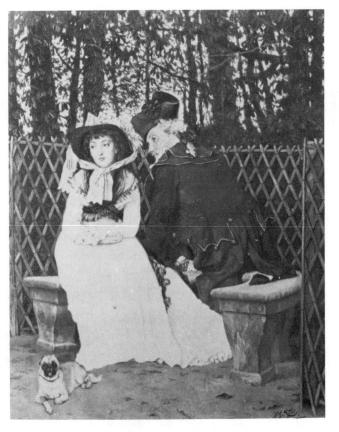

I-67: Unidentified Directoire subject, 1869

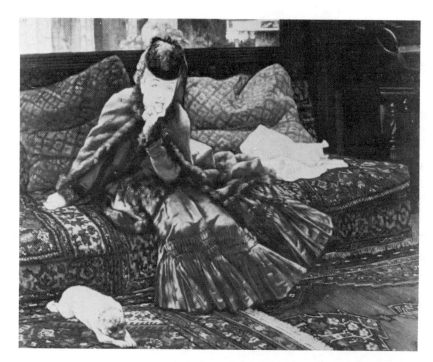

I-68: *Rêverie*, 1869

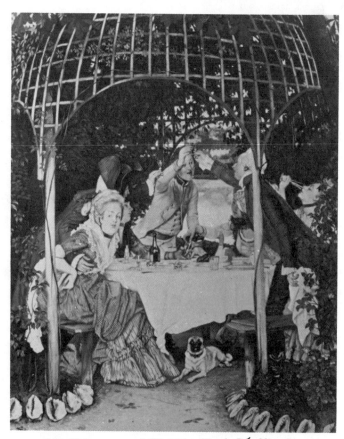

I-69: *Un souper sous le Directoire (Vive la République!)*,
1869-70

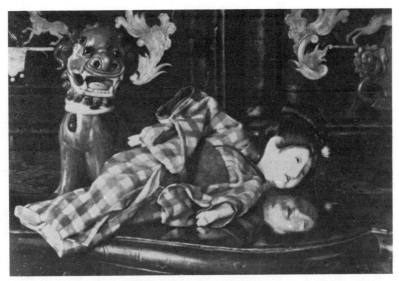

I-70: Still-life of Japanese objects

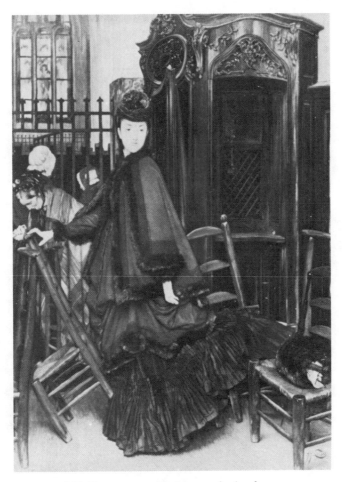

I-71: Young woman leaving a confessional

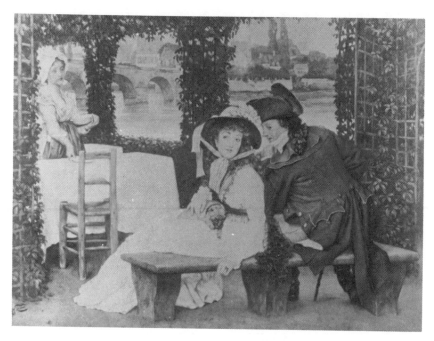

I-72: Unidentified Directoire subject

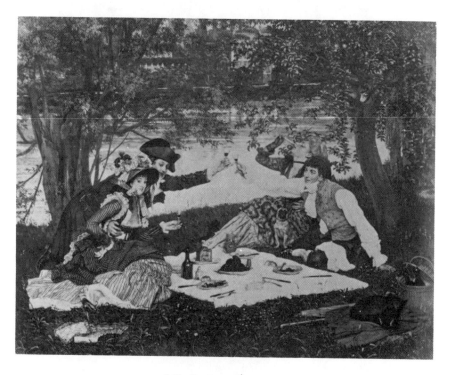

I-73: *Partie carrée,* 1870

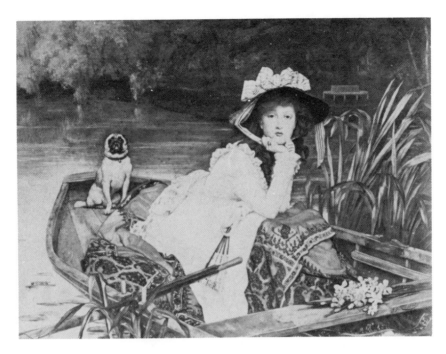

I-74: *Jeune femme en bateau,* 1870

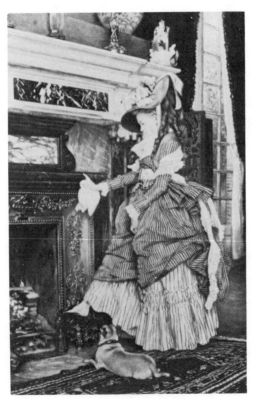

I-75: *By the Fireside*

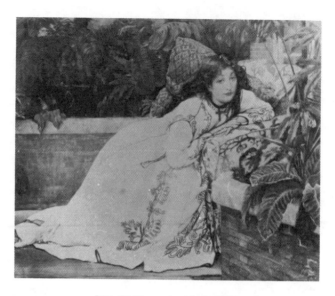

I-76: *Girl in an Armchair,* 1872

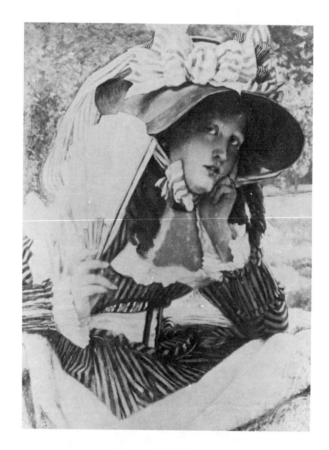

I-77: *Woman with a Fan*

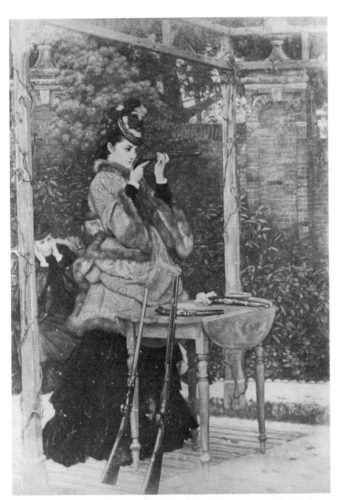

I-78: *Safe to Win*

I-79: *Woman Holding*
Japanese Objects

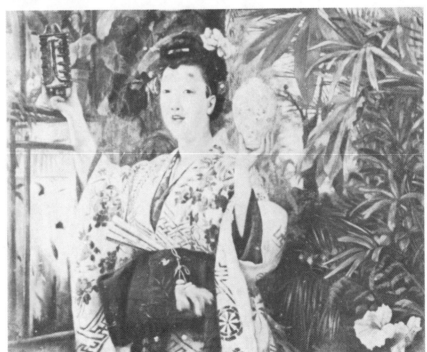

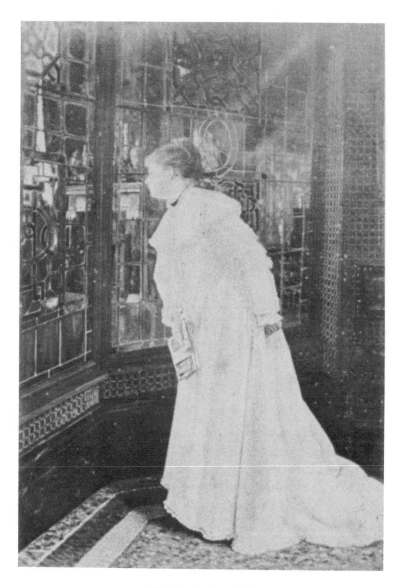

I-80: *The Staircase*, 1869

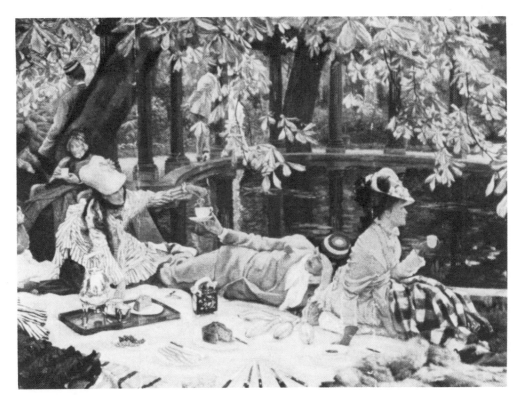

I-81: Reproduction of *The Picnic (Holyday)*, 1877

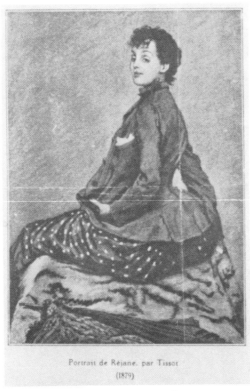

Portrait de Réjane, par Tissot
(1879)

I-82: Reproduction of a portrait of Réjane, dated 1879

Album II
1871-1878

(Album missing)

Album III
1878-1882

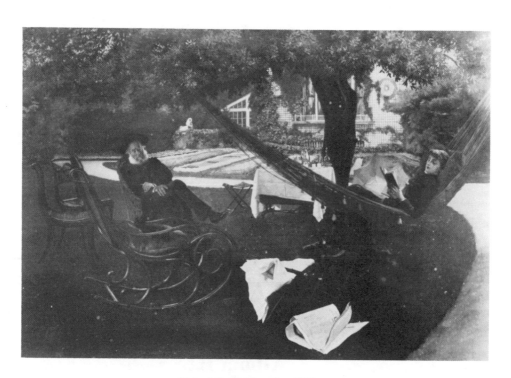

III-1: *A Quiet Afternoon*, 1879

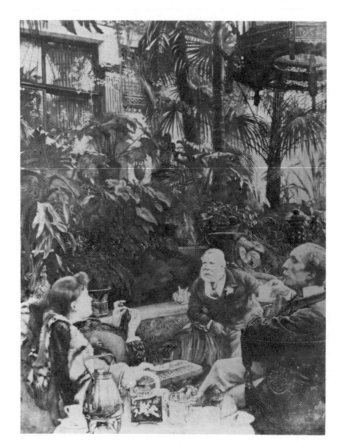

III-2: *Rivals*, 1879

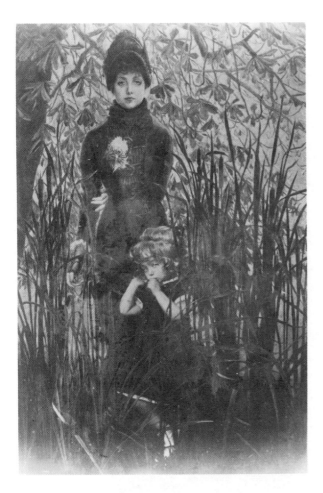

III-3: *The Orphan,* 1878

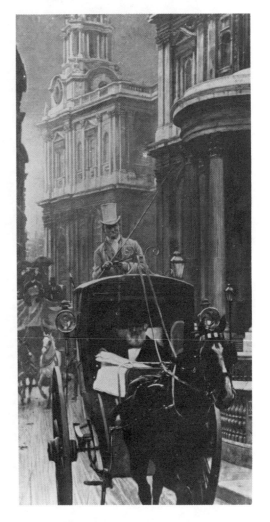

III-4: *Going to Business,* 1879

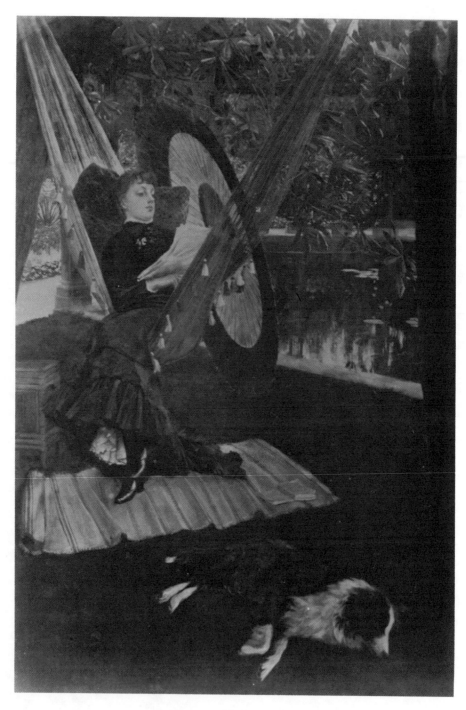

III-5: *The Hammock*, 1879

54

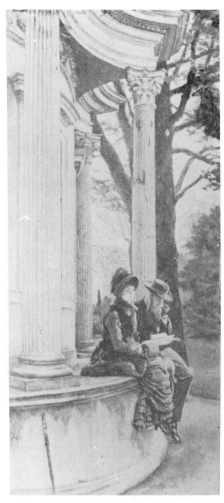

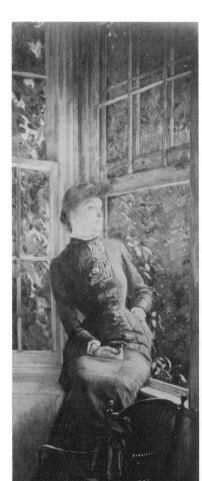

III-7: *The Bow Window*

III-6: *Kew Gardens*

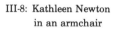

III-8: Kathleen Newton
in an armchair

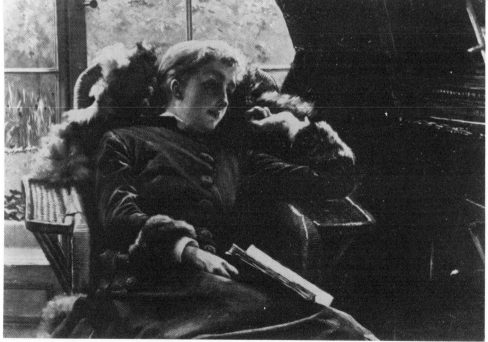

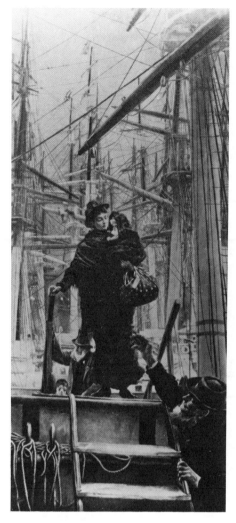

III-9: *Emigrants*, 1879

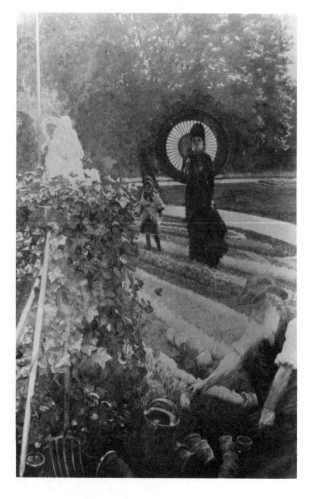

III-10: *The Gardener*, 1879

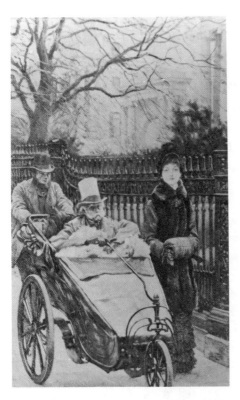

III-11: *The Convalescent,* ca. 1878

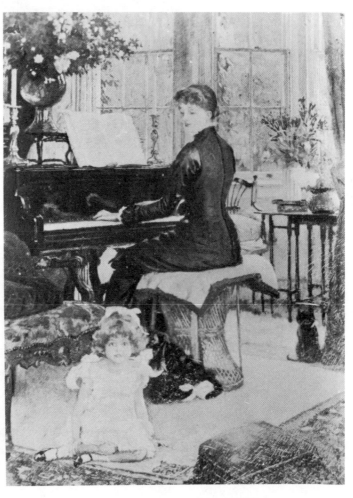

III-12: *Do, re, me, fa, sol, la, te, do!* (?)

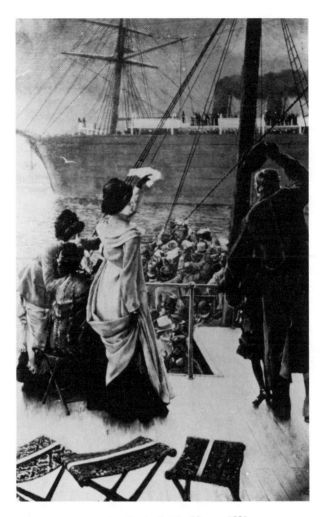

III-13: *'Goodbye'—On the Mersey*, 1881

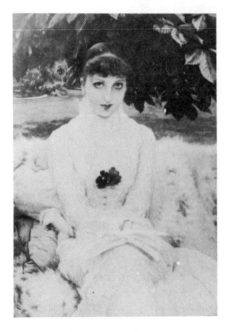

III-14: Kathleen Newton in the garden

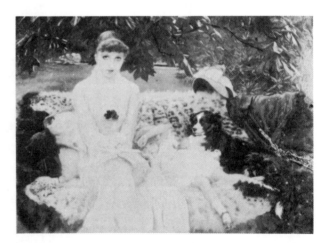

III-15: *Quiet*, 1881

58

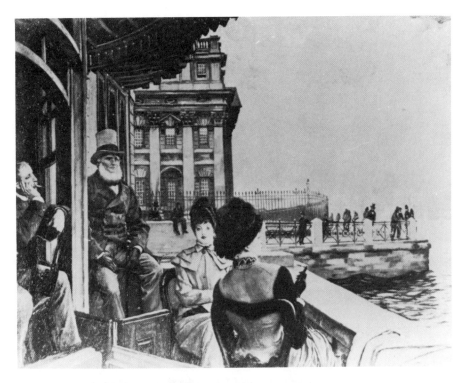

III-16: *At the Trafalgar Tavern*

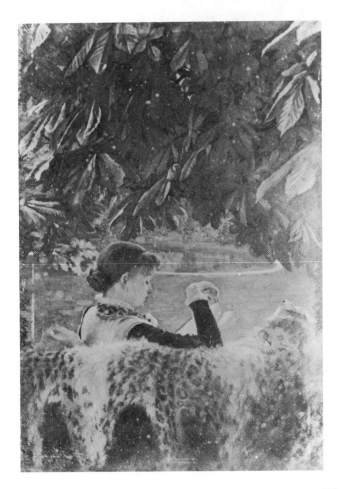

III-17: *The Tale*
(Le Conte)

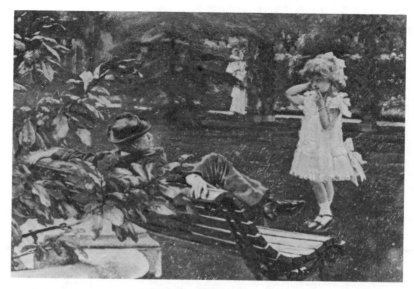

III-18: *Uncle Fred*, 1880

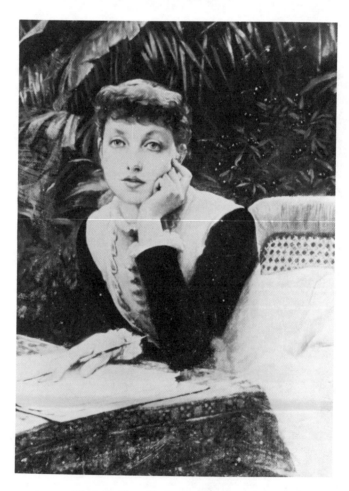

III-19: Kathleen Newton in the conservatory

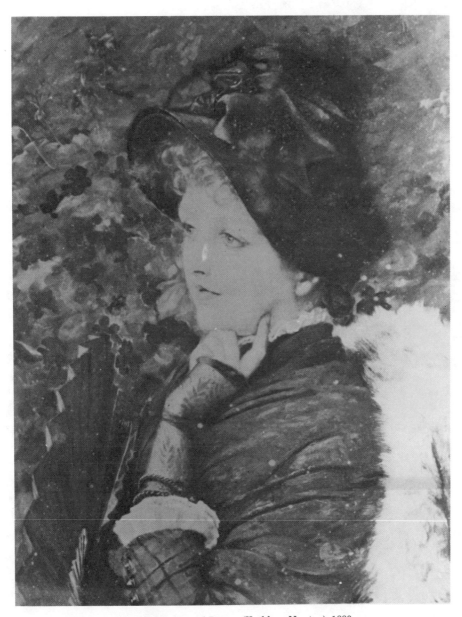

III-20: *Type of Beauty* (Kathleen Newton), 1880

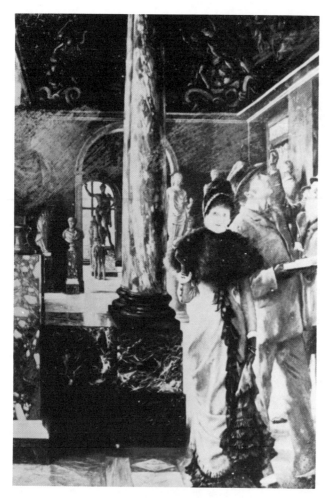

III-21: *Visitors to the Louvre*, 1879

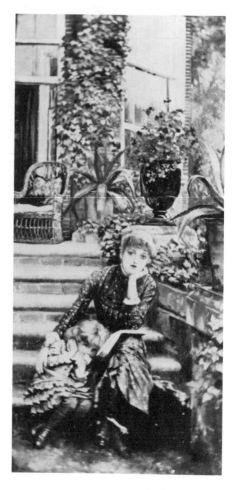

III-22: *La soeur aînée*

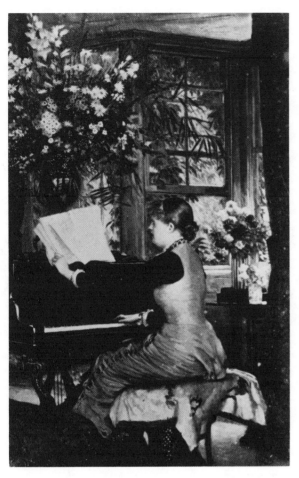

III-23: *Woman at the Piano*

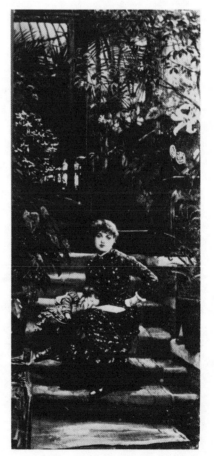

III-24: La soeur aînee

63

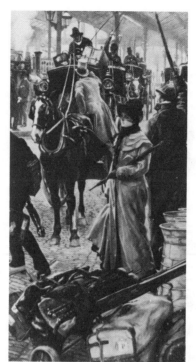

III-25: *Departure Platform,*
Victoria Station

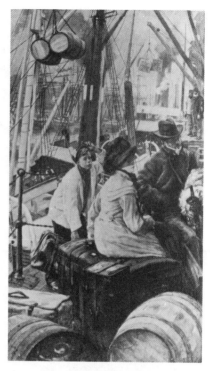

III-26: *Un quai d'*
embarquement à Londres

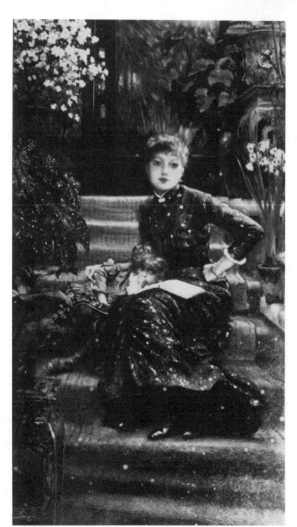

III-27: *La soeur aînée*

64

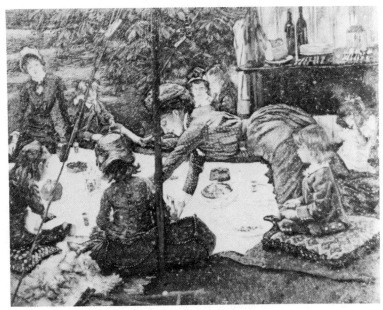

III-28: *Children's Picnic*

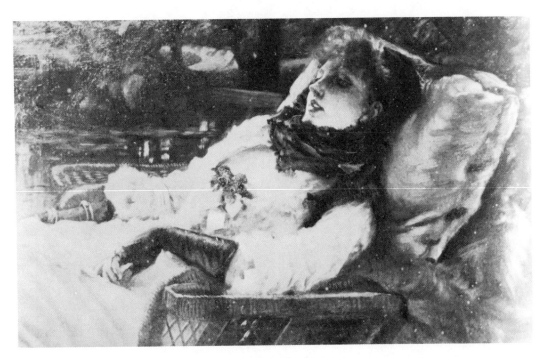

III-29: *Soirée d'été*

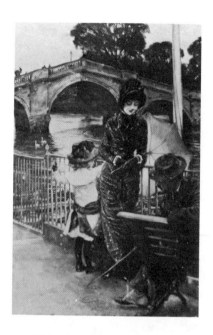

III-30: At Richmond Bridge

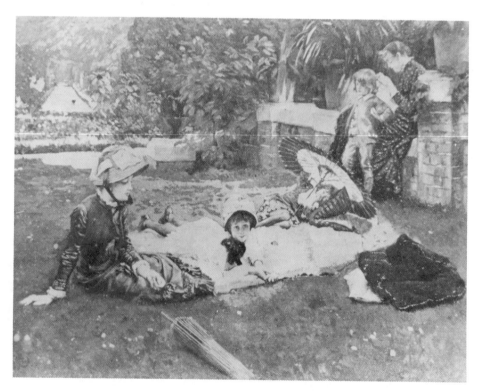

III-31: *En plein soleil (In the Sunlight)*

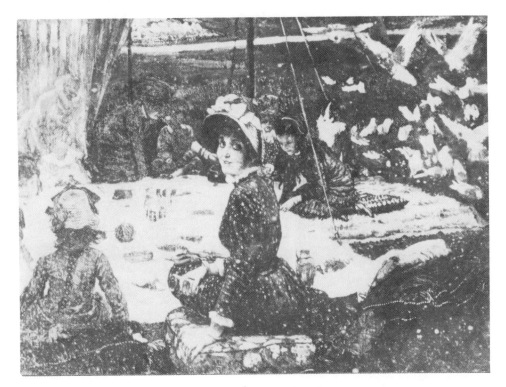

III-32: *Le déjeuner sur l' herbe*

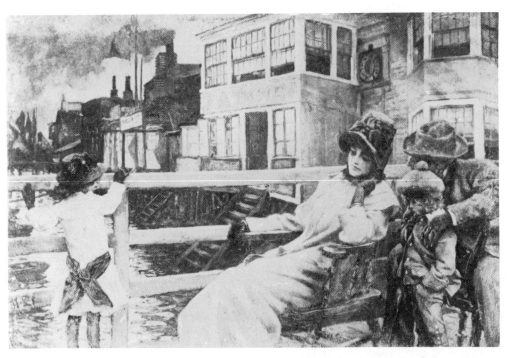

III-33: *Waiting for the Ferry*

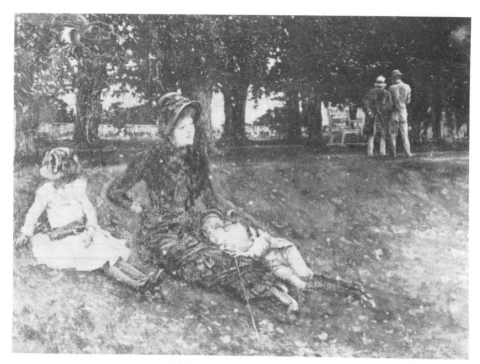

III-34: *Le repos dans un parc*

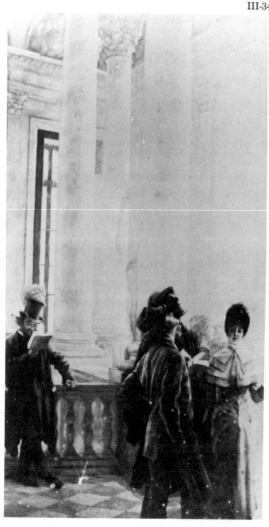

III-35: *L' escalier nord
du Louvre,* 1879

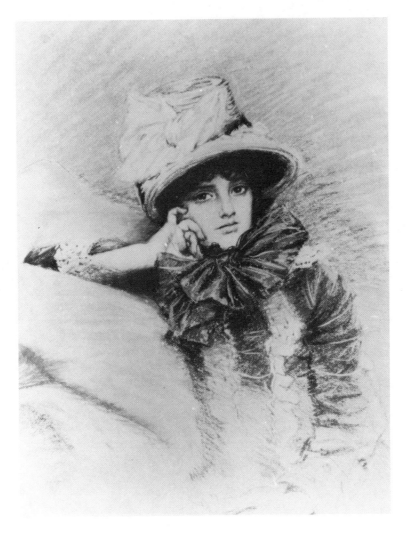

III-36: *Berthe*

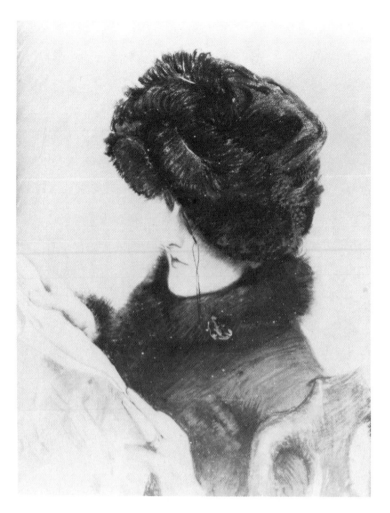

III-37: *La liseuse (Le journal)*

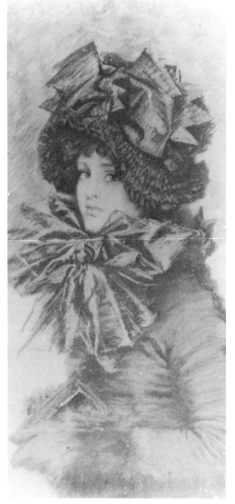

III-38: *Dimanche matin*

70

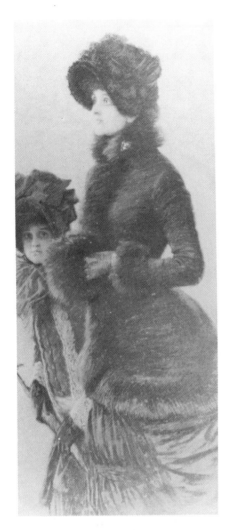

III-39: *Promenade du matin*

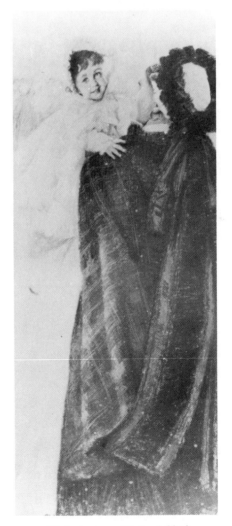

III-40: A nurse with the child of
Georges Petit

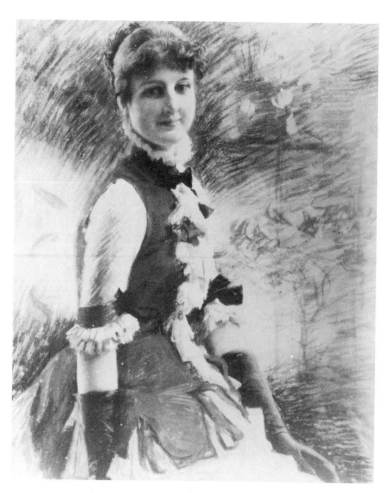

III-41: *Portrait of an unidentified lady*

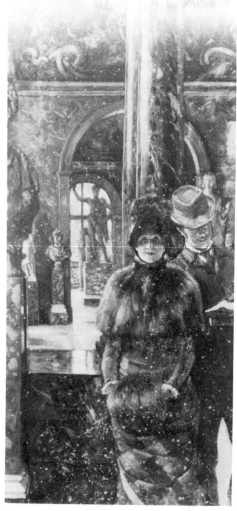

III-42: *Visitors to the Louvre,* 1879

72

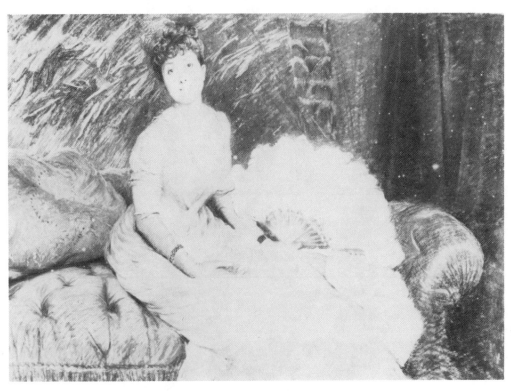

III-43: Portrait of an unidentified lady

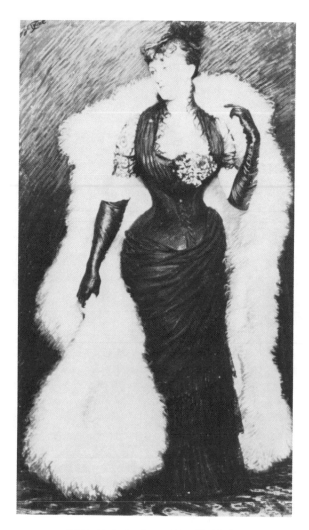

III-44: Portrait of an unidentified lady

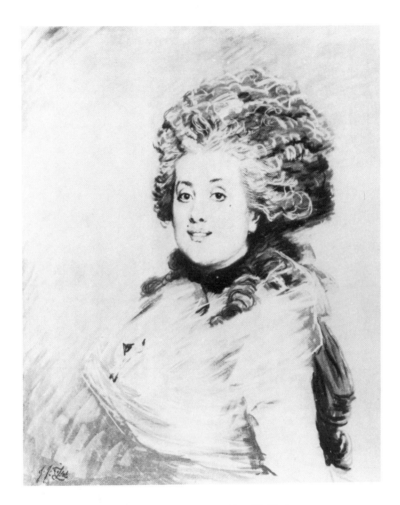

III-45: Portrait of an unidentified lady

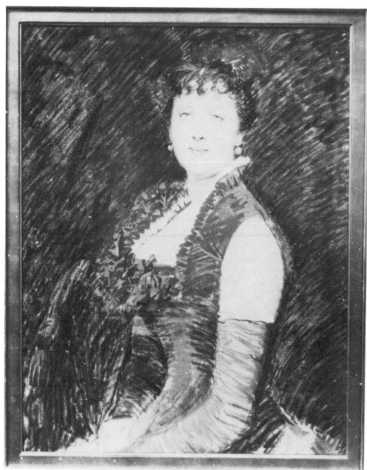

III-46: Portrait of an unidentified lady

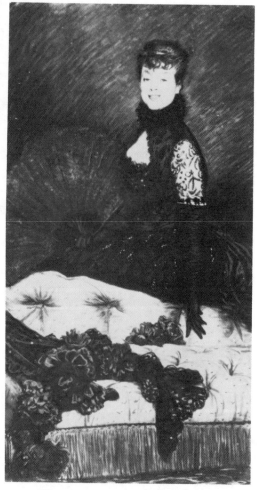

III-47: Portrait of an unidentified lady

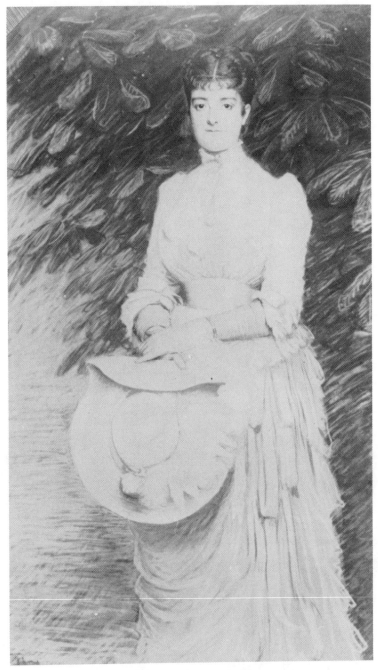

III-48: Portrait of an unidentified lady

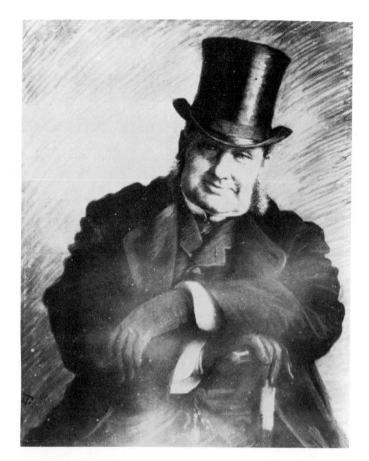

III-49: Portrait of an unidentified gentleman

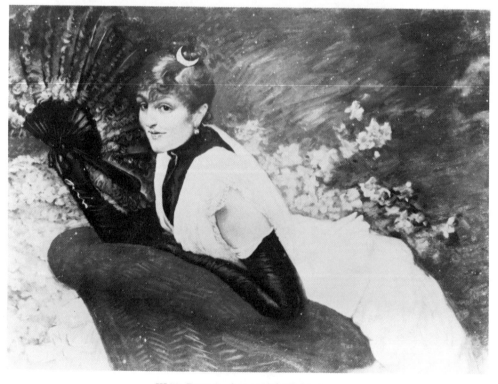

III-50: Portrait of an unidentified lady

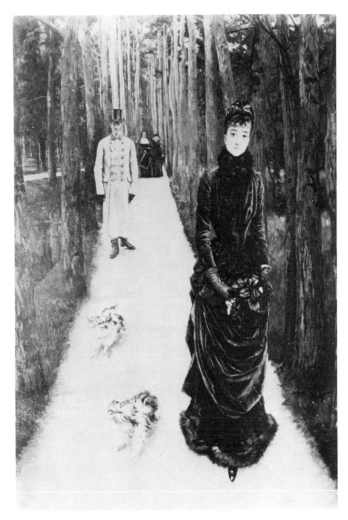

III-51: *La Femme à Paris: La Mystérieuse,*
1883-85

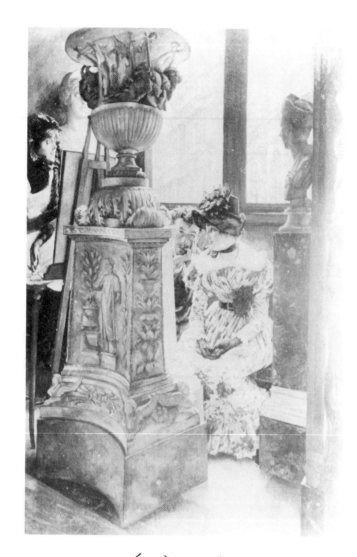

III-52: *L'Étrangère: L'Esthétique*, 1883-85

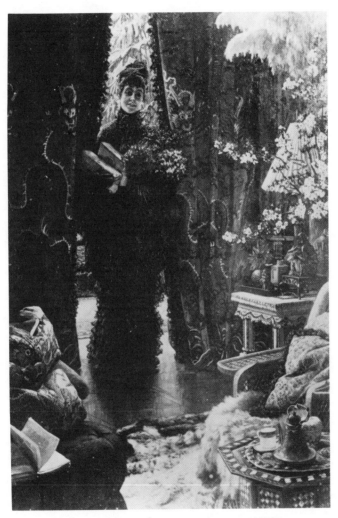

III-53: *La Femme à Paris: La Menteuse,* 1883-85

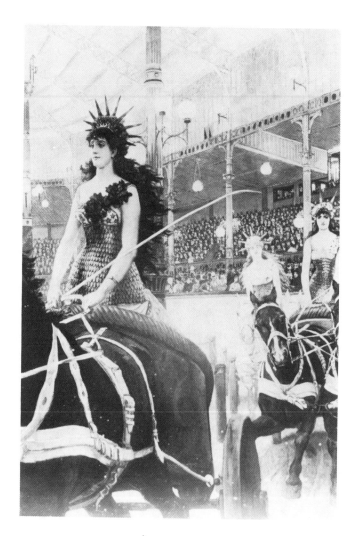

III-54: *La Femme à Paris: Ces Dames des Chars*, 1883-85

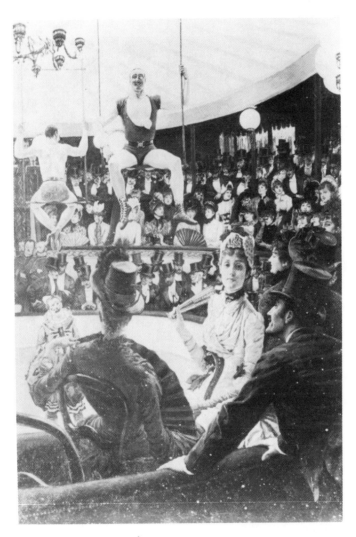

III-55: *La Femme à Paris: Les Femmes de sport*, 1883-85

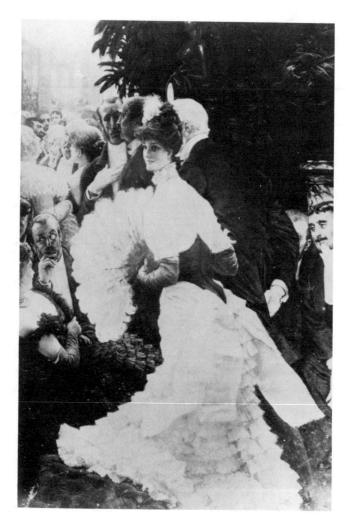

III-56: *La Femme à Paris: L'Ambitieuse*, 1883-85

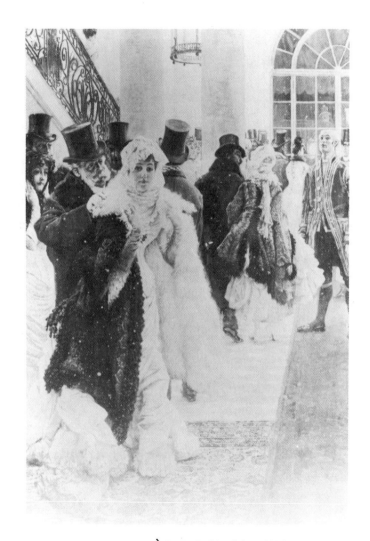

III-57: *La Femme à Paris: La Mondaine*, 1883-85

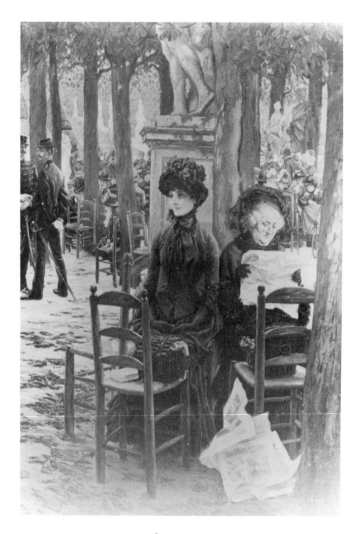

III-58: *La Femme à Paris: Sans dot,* 1883-85

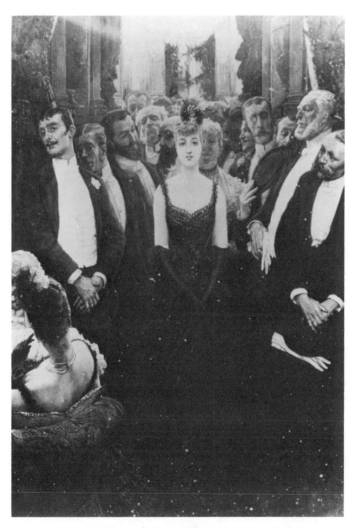

III-59: *La Femme à Paris: La plus jolie femme de Paris,*
1883-85

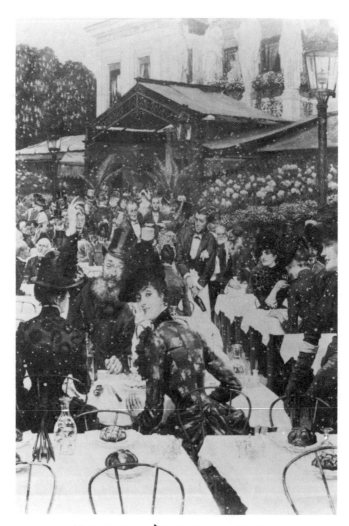

III-60: *La Femme à Paris: Femmes d'Artistes,*
1883-85

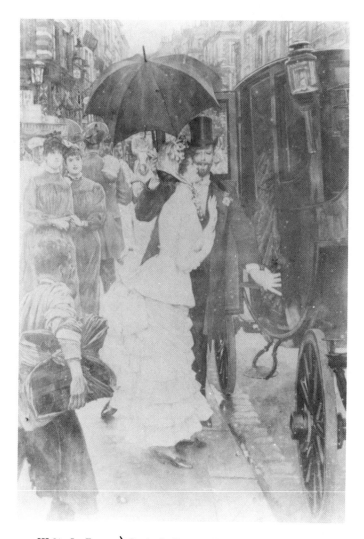

III-61: *La Femme à Paris: La Demoiselle d'honneur*, 1883-85

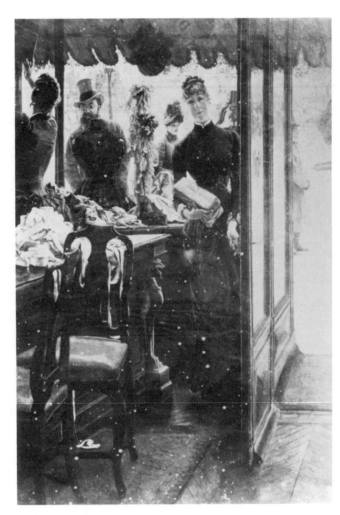

III-62: *La Femme à Paris: La Demoiselle de Magasin,*
1883-85

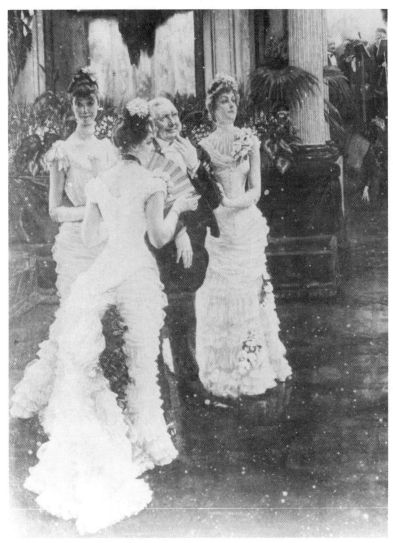

III-63: *La Femme à paris: Les Demoiselles de Province*, 1883-85

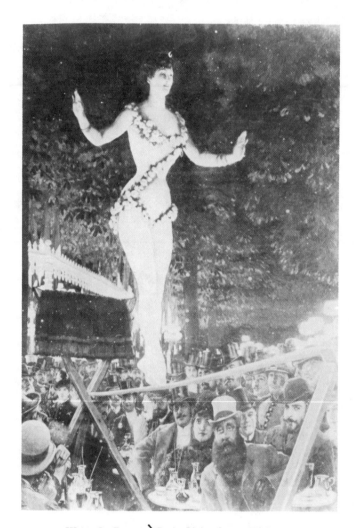

III-64: *La Femme à Paris: L' Acrobate*, 1883-85

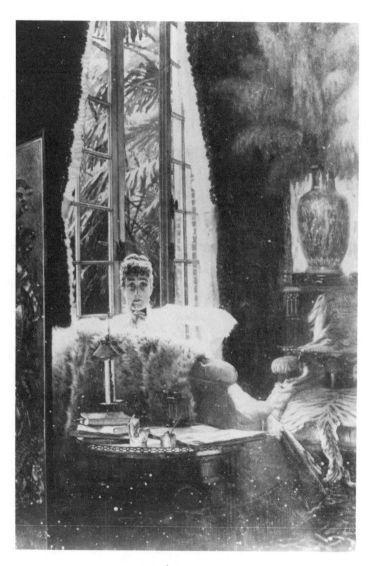

III-65: *La Femme à Paris: Le Sphinx*, 1883-85

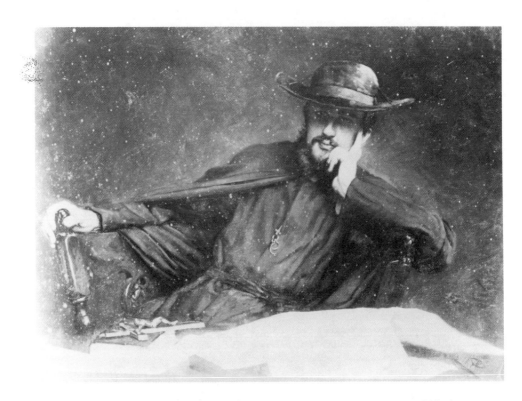

III-66: *Portrait du Réverend Père B..., Missionaire au Gabon* (Father Bichet)

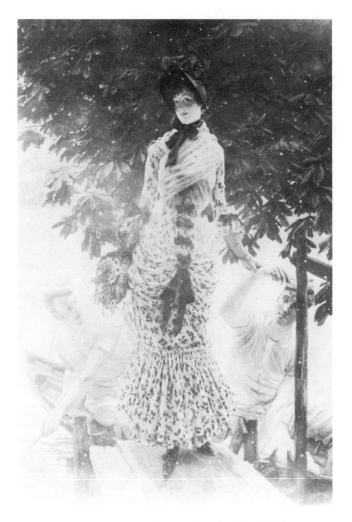

III-67: *Sur la Tamise (Return from Henley)*, 1883-85

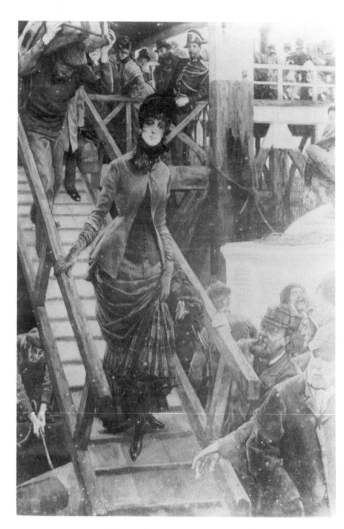

III-68: *L' Etrangère: La Voyageuse*, 1883-85

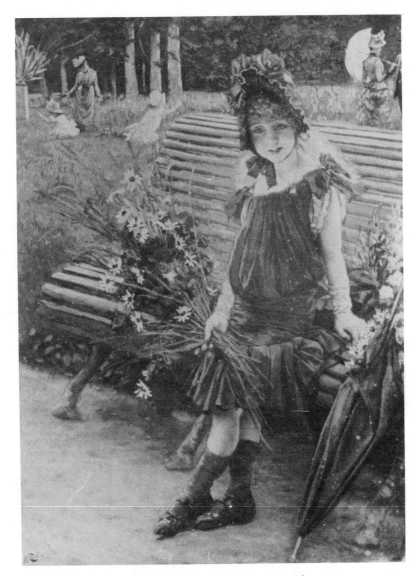

III-69: Portrait of an unidentified girl

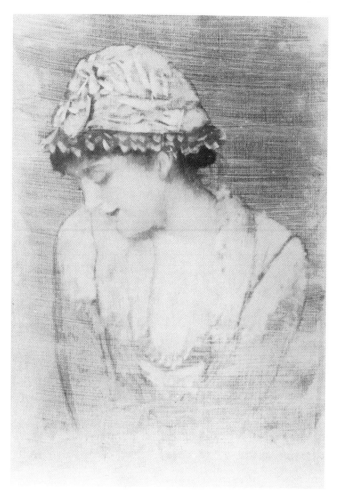

III-70: Sketch of a woman

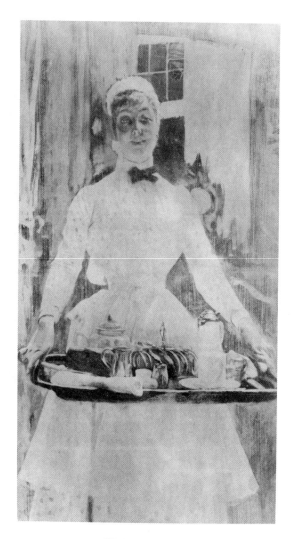

III-71: *Le Matin*

Album IV
1882-1902

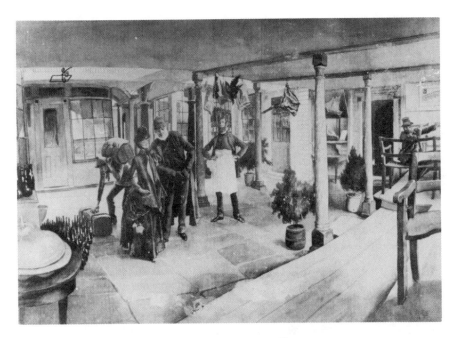

IV-1: *The Falcon Inn* (?)

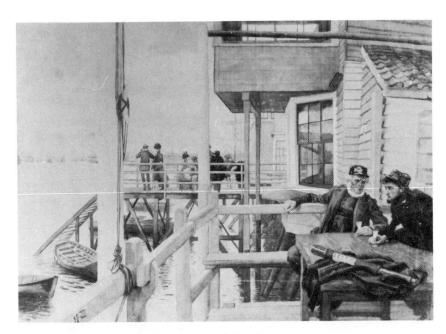

IV-2: *The Falcon Inn*

101

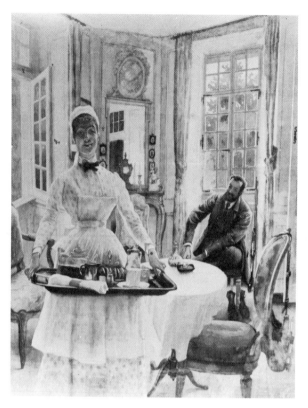

IV-3: *Le Déjeuner du matin*

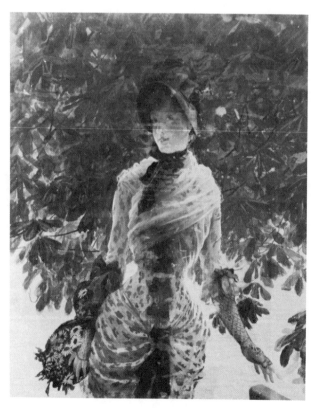

IV-4: *Sur la Tamise* (watercolor after III-67)

102

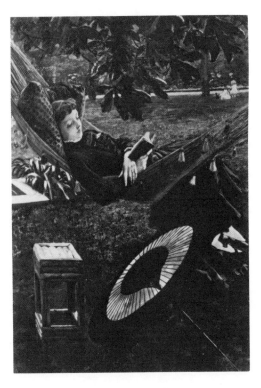

IV-5: *The Hammock*

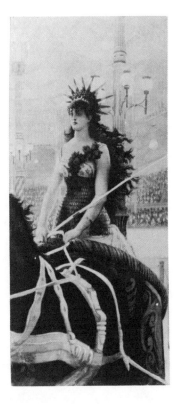

IV-6: *Une de ces Dames des chars*

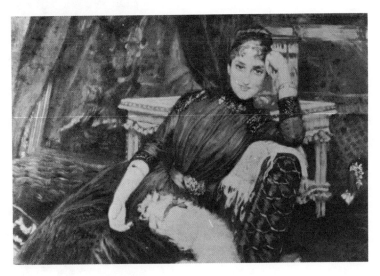

IV-7: Portrait of an unidentified lady

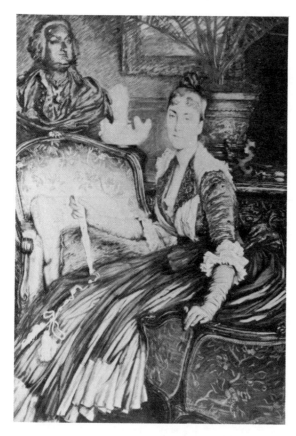

IV-8: Portrait of an unidentified lady

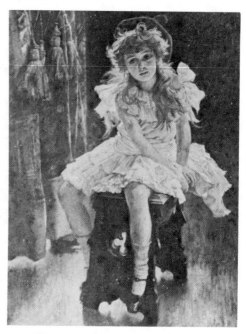

IV-9: Portrait of an unidentified girl

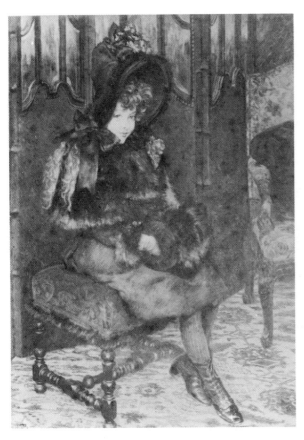

IV-10: Portrait of an unidentified girl

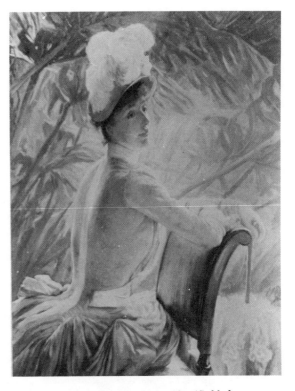

IV-11: Portrait of an unidentified lady

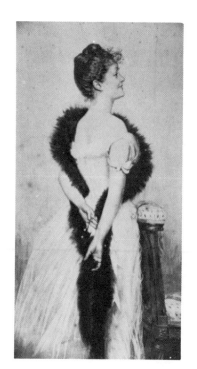

IV-12: *La Vicomtesse
de Montmorand*
(Geneviève de Miramon), 1882

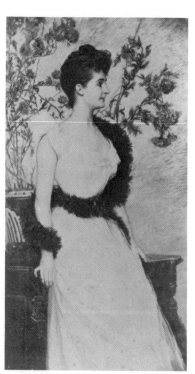

IV-13: *La Vicomtesse de Montmorand,*
1882

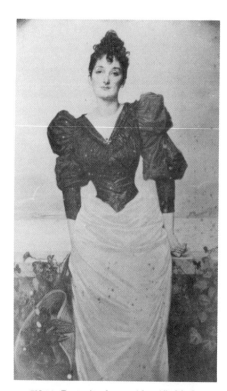

IV-14: Portrait of an unidentified lady

IV-15: Portrait of an unidentified gentleman in
Renaissance costume

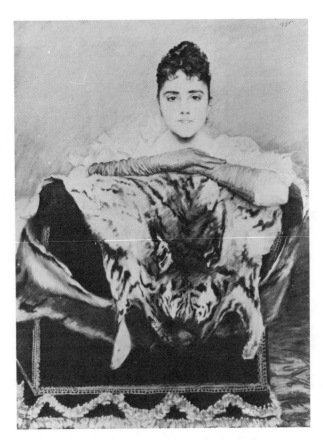

IV-16: Portrait of an unidentified lady, 1886

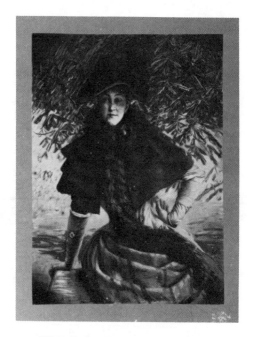

IV-17: Portrait of an unidentified lady

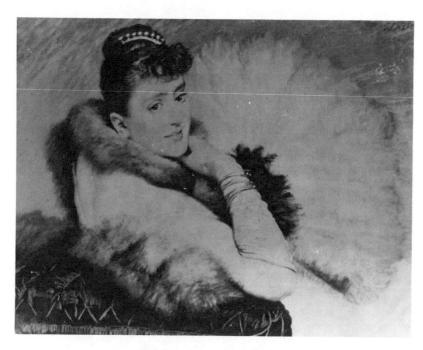

IV-18: Portrait of an unidentified lady

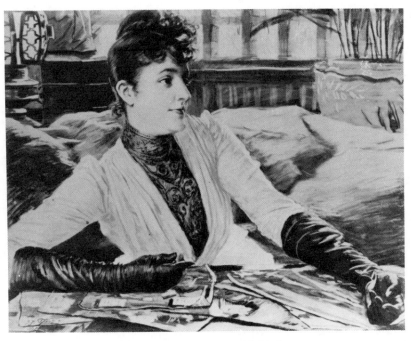

IV-19: Portrait of an unidentified lady

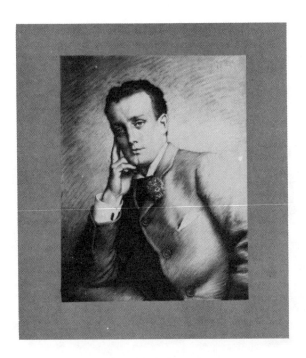

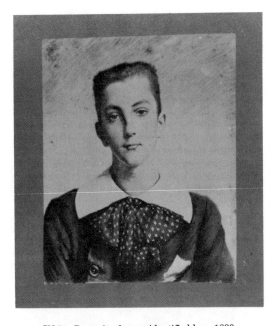

IV-21: Portrait of an unidentified boy, 1890

IV-20: Portrait of an unidentified young man

109

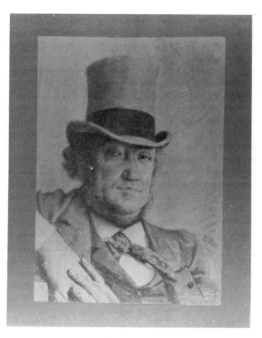

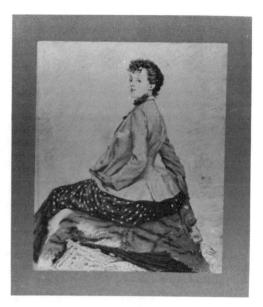

IV-23: *Réjane*

IV-22: Portrait of an unidentified gentleman, 1889

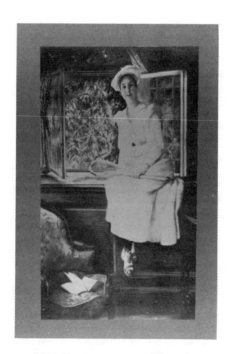

IV-24: Young woman, possibly a niece
of the artist, seated in the sun room of the
abbatiale studio at Buillon

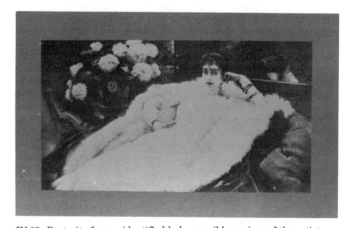

IV-25: Portrait of an unidentified lady, possibly a niece of the artist

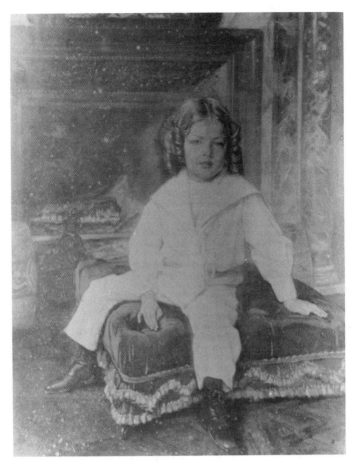

IV-26: Portrait of an unidentified boy

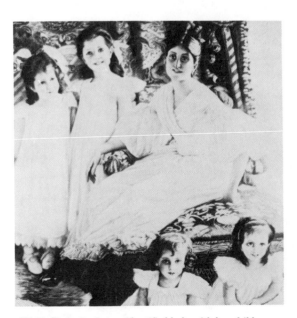

IV-27: Portrait of an unidentified lady with her children

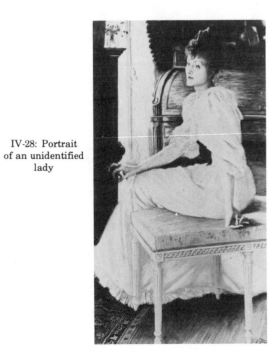

IV-28: Portrait
of an unidentified
lady

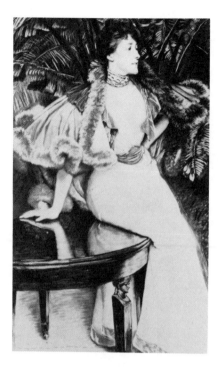

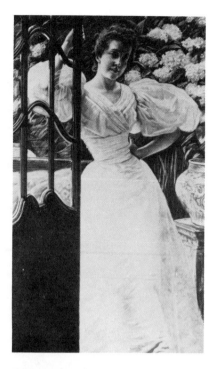

IV-29: Portrait of an unidentified lady

IV-30: Portrait of an unidentified lady, 1895

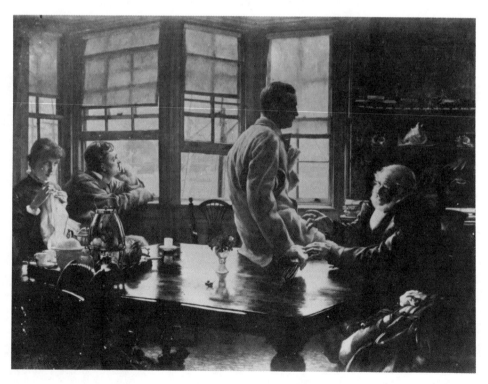

IV-31: *The Prodigal Son in Modern Life: The Departure*, 1882

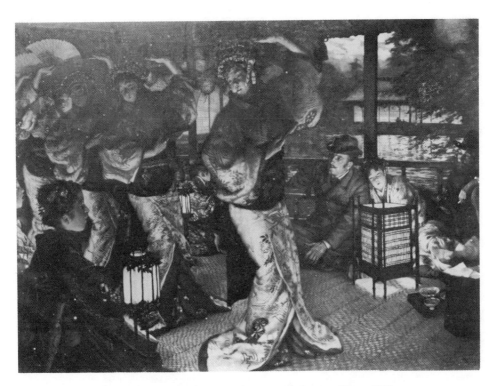

IV-32: *The Prodigal Son in Modern Life: In Foreign Climes*, 1882

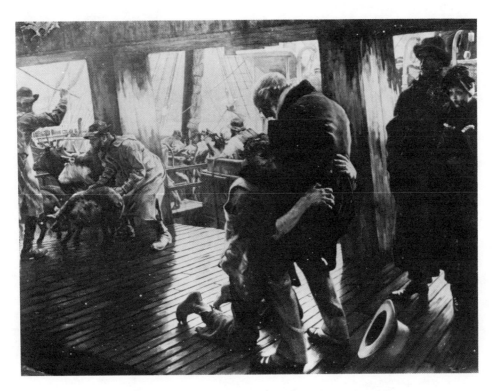

IV-33: *The Prodigal Son in Modern Life: The Return*, 1882

113

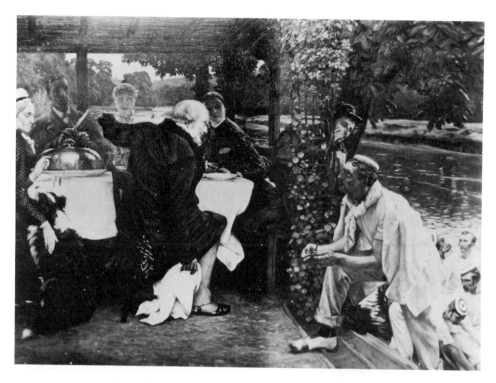

IV-34: *The Prodigal Son in Modern Life: The Fatted Calf,* 1882

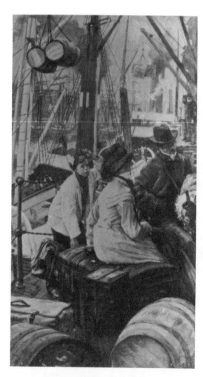

IV-35: *Un quai d' embarquement à Londres*

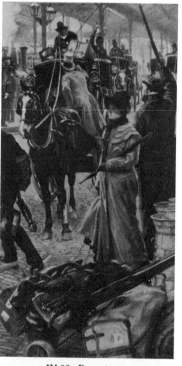

IV-36: *Departure Platform, Victoria Station*

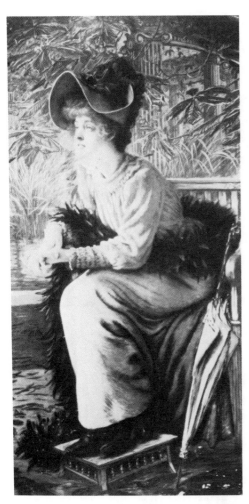

IV-37: Young woman seated

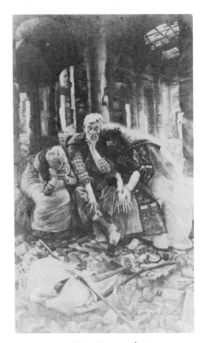

IV-38: *Christ le consolateur*
(*Christ the Comforter,*) 1884-85

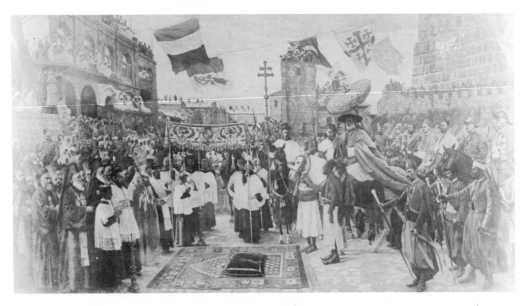

IV-39: *La réception à Jérusalem du légat apostolique du Saint-Siège, S. Em. Monseigneur le Cardinal Langénieux,*
par le patriarche S.-B. Monseigneur Piavi

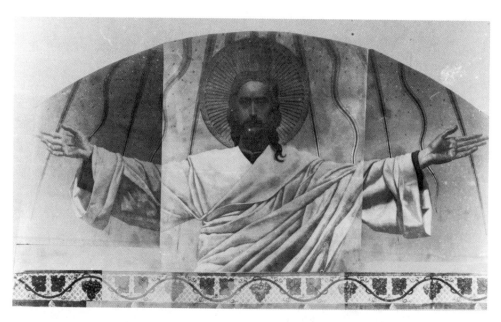

IV-40: *Colossal Christ,* Couvent des Dominicains, rue du Faubourg St.-Honoré, Paris, 1898

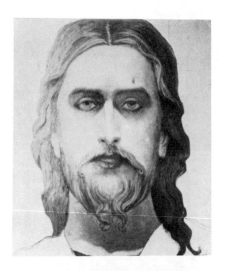

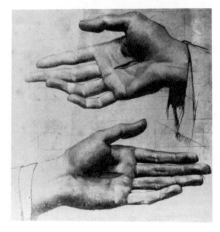

IV-41: Studies for the head and hands of Christ

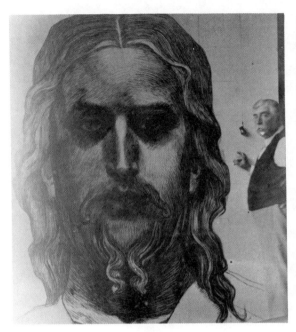 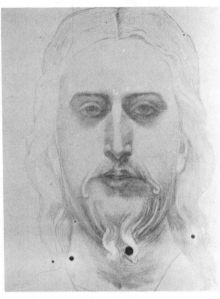

IV-42: Photos of Tissot with the full scale cartoon for the head of Christ

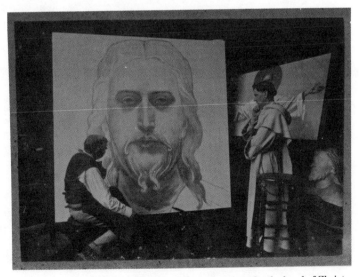

IV-43: Tissot and a monk with the full scale cartoon for the head of Christ

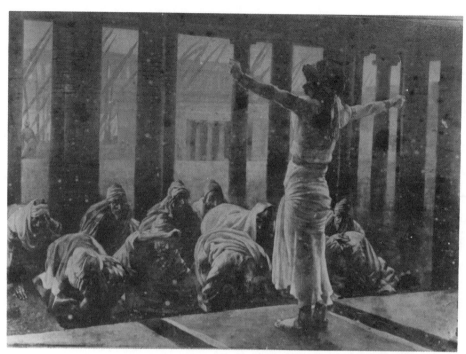

IV-44: *The Old Testament: Joseph Maketh Himself Known to his Brethren*
(alternate version)

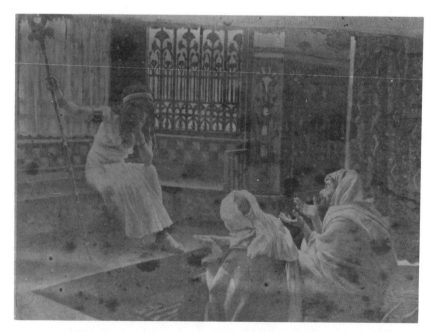

IV-45: *The Old Testament: Joseph Converses with his Brother Judah*
(alternate version?)

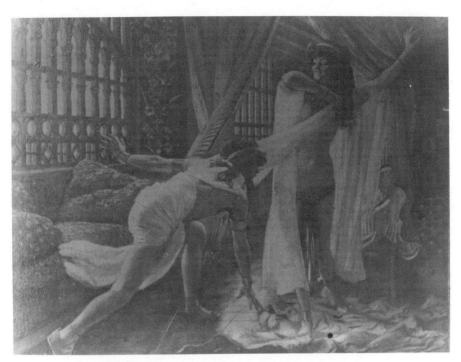

IV-46: *The Old Testament: Joseph and the Wife of Potiphar*

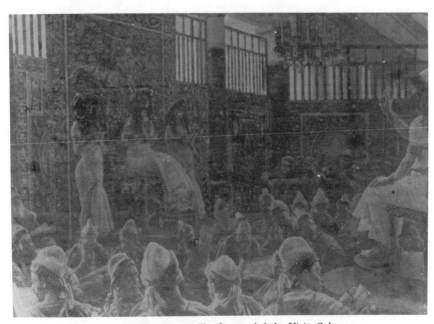

IV-47: *The Old Testament: The Queen of sheba Visits Solomon*
(alternate version)

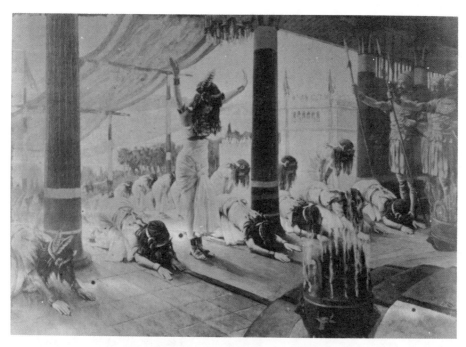

IV-48: *The Old Testament: The Queen of Sheba Visits Solomon*
(alternate version)

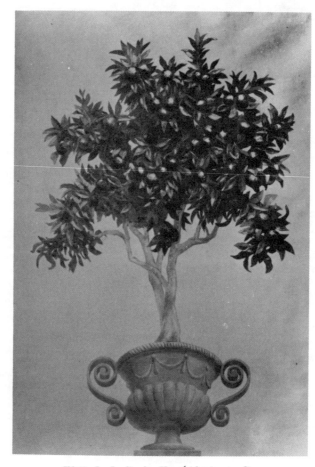

IV-49: *Le Jardin des Hespérides* (orange?)

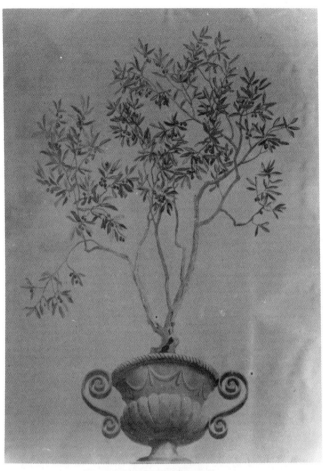

IV-50 *Le Jardin des Hespérides* (olive)

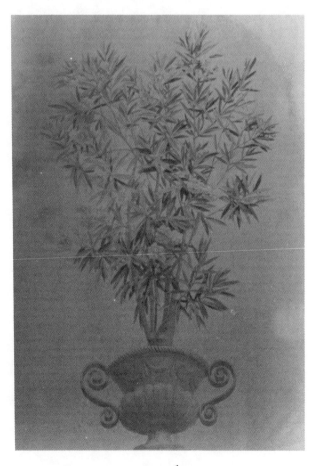

IV-51: *Le Jardin des Herspérides* (oleander)

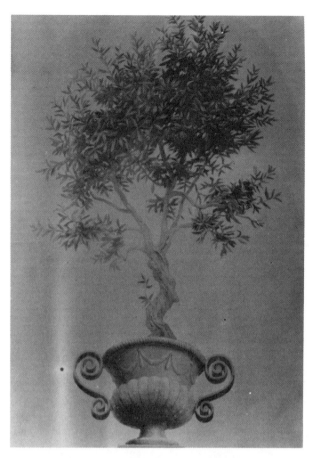

IV-52: *Le Jardin des Hespérides* (pomegranate)

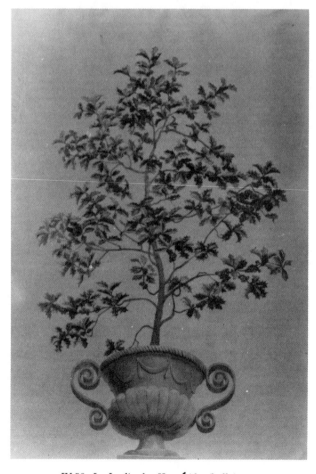

IV-53: *Le Jardin des Hespérides* (holly)

122

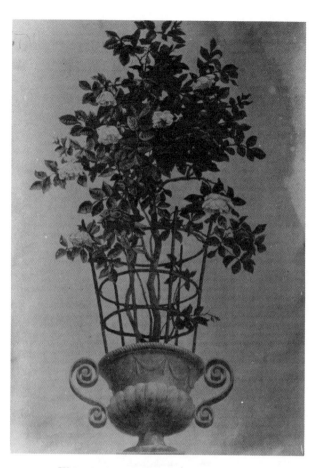

IV-54: *Le Jardin des Hespérides* (rose)

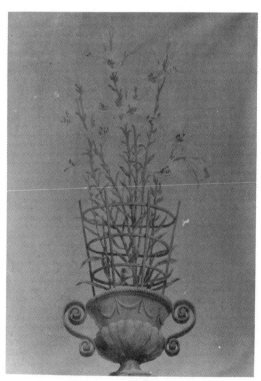

IV-55: *Le Jardin des Hespérides* (tuberose)

123

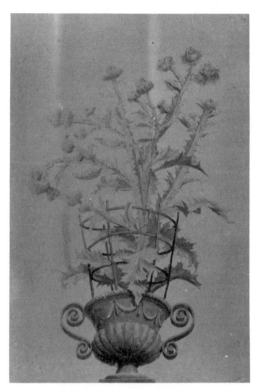

IV-56: *Le Jardin des Hespérides* (thistle)

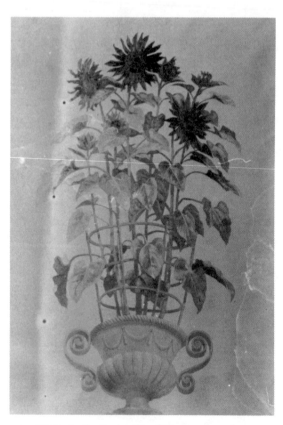

IV-57: *Le Jardin des Hespérides* (sunflower)

IV-58: Portrait of the artist, after a photograph

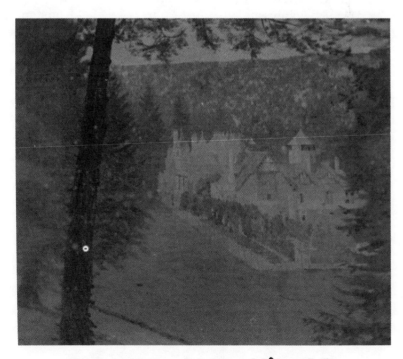

IV-59: The greenhouse, studio building and château at Buillon

Check-list of Locations of Works
Recorded in the Albums

Although incomplete, this check-list may serve as a convenience to the reader. A number of the works reported in the albums have changed hands recently, but, regrettably, it has not been possible to trace them.

I-5: Private collection, Paris
I-11: Rhode Island School of Design
I-13: Art Gallery of Hamilton, Ontario
I-14: Private collection, Washington, D.C.
I-15: Louvre, Paris (Mairie de Chambon-Feugerolles)
I-20: Private collection, Arlington, Virginia
I-21: National Gallery of Ireland
I-22: Sotheby's, New York
I-28: Louvre, Paris
I-29: Louvre, Paris
I-33: Stanford University Museum of Art
I-35: Musée de Dijon
I-36: Private collection, Paris
I-37: Private collection, Paris
I-40: Southampton Art Gallery
I-49: Philadelphia Museum of Art
I-57: Kurt E. Schon, Ltd., New Orleans
I-59: Musée de Nantes
I-65: Private collection, Cincinnati
I-66: Dealer, New York
I-68: Pennsylvania Academy of the Fine Arts
I-69: Baroda Museum and Picture Gallery, India
I-73: Private collection, Zurich
I-75: Private collection, New York
I-76: Art Gallery of Ontario
I-77: British Embassy, Paris
I-78: Wimpole Hall, Hertfordshire, England
I-80: Private collection, Toronto

III-3: Private collection, London
III-11: City Art Gallery, Manchester, England
III-13: Two versions exist: Forbes Collection, New York, and private collection, London
III-14: Musée Magnin, Dijon
III-15: Private collection, London
III-17: Private collection, France
III-18: Private collection, France
III-29: Musée de Metz, France
III-32: Musée de Dijon
III-36: Petit Palais, Paris
III-52: Museo de Arte Ponce, Puerto Rico
III-54: Rhode Island School of Design
III-55: Museum of Fine Arts, Boston
III-56: Albright-Knox Art Gallery, Buffalo
III-57: Private collection, Toronto
III-58: Private collection, Toronto
III-59: Private collection, Geneva
III-60: Chrysler Museum, Norfolk
III-61: Leeds City Art Gallery
III-62: Art Gallery of Ontario
III-66: Musée de Nantes
III-67: Newark Museum, Newark, NJ
III-68: Koninklijk Museum voor Schone Kunsten, Antwerp
IV-6: Musée de Dijon
IV-12: Private collection, Paris
IV-31: Musée de Nantes
IV-32: Musée de Nantes
IV-33: Musée de Nantes
IV-34: Musée de Nantes
IV-38: The Hermitage, Leningrad
IV-40: Couvent des Dominicains, rue du Faubourg St-Honoré, Paris
IV-58: Private collection, France
IV-59: Private collection, France